John Ruskin

Very Interesting People

VIP

Bite-sized biographies of Britain's most fascinating historical figures

John Ruskin

Very Interesting People

Robert Hewison

OXFORD
UNIVERSITY PRESS

OXFORD
UNIVERSITY PRESS

Great Clarendon Street, Oxford ox2 6DP

Oxford University Press is a department of the University of Oxford.
It furthers the University's objective of excellence in research, scholarship,
and education by publishing worldwide in

Oxford New York

Auckland Cape Town Dar es Salaam Hong Kong Karachi
Kuala Lumpur Madrid Melbourne Mexico City Nairobi
New Delhi Shanghai Taipei Toronto

With offices in

Argentina Austria Brazil Chile Czech Republic France Greece
Guatemala Hungary Italy Japan Poland Portugal Singapore
South Korea Switzerland Thailand Turkey Ukraine Vietnam

Oxford is a registered trade mark of Oxford University Press
in the UK and in certain other countries

Published in the United States
by Oxford University Press Inc., New York

First published in the *Oxford Dictionary of National Biography* 2004
This paperback edition first published 2007

© Oxford University Press 2007

Database right Oxford University Press (maker)

First published 2007

British Library Cataloguing in Publication Data

Data available

Library of Congress Cataloging in Publication Data

Data available

Typeset by SPI Publisher Services, Pondicherry, India
Printed in Great Britain
on acid-free paper by
Ashford Colour Press Ltd., Gosport, Hants.

ISBN 978–0–19–921349–8 (Pbk.)

10 9 8 7 6 5 4 3 2 1

Contents

Preface

When the editors of the *Oxford Dictionary of National Biography* were deciding whom to include in their new edition, it was inevitable that John Ruskin should be selected. But historical reputations can decline as well as rise over time. What was not inevitable therefore was that Ruskin's new entry in the *Oxford DNB* should be almost exactly the same length as that published in the dictionary's first edition in 1901.

The task of writing the original Ruskin entry was given to Edward Tyas Cook, the Liberal journalist who, with Alexander Wedderburn, was the editor of the literally monumental Library edition of *The Complete Works of John Ruskin* (1903–12). Cook's account is by no means a hagiography, though it does rely on Ruskin's own version of

himself in *Praeterita*, and is understandably circumspect about his sex life. What can be said about that troubled aspect of his life is given more consideration here.

More importantly, Cook sought to reconstruct Ruskin as a political liberal, a forerunner of the social reformers who claimed to be his heirs. Here Ruskin's tory roots are recovered. This does not change the reality of Ruskin's role as a god-father to the Labour Party and the welfare state, but it is important to appreciate where Ruskin's puritan radicalism came from. By the same token, I have given more attention to summarizing Ruskin's ideas, in order to explain the consistency of his aesthetic principles with his evolving social argument.

Ruskin's achievements merit the space the editors of *Oxford DNB* have afforded them, but it is also true that a more than academic interest in Ruskin has been steadily growing since the 1950s. This short biography was written for the *Oxford DNB* during the preparations for Ruskin's centenary. An informal body, Ruskin To-Day, was set up to co-ordinate the celebrations, and has remained in

being. In September 2006 a conference and publication, *'There Is No Wealth But Life': Ruskin in the 21st Century* explored the practical possibilities of Ruskin's legacy.

E. T. Cook was helped and hindered by the fact that he had seen and heard Ruskin in person. The most important aspect of this great man, his personality, is no longer directly accessible. It is only right, and respectful, therefore, to close by quoting Cook. Ruskin, he wrote, was 'whimsical, paradoxical, dictatorial, incalculable. There was always a flash of irony playing about his talk, which puzzled, teased, or delighted his listeners according to their temperament. His charm of manner was irresistible'. Hence the length of this brief life.

Robert Hewison
August 2006

About the author

Robert Hewison is a trustee of the Ruskin Foundation and Professor of Cultural Policy and Leadership Studies at City University, London. His many books include *John Ruskin: The Argument of the Eye* and *Culture and Consensus: England, Art and Politics since 1940*; he is currently working on a study of 'Venice and Ruskin', to be published in 2009.

Childhood and education

1

John Ruskin (1819–1900),

art and social critic, was born on 8 February 1819 at 54 Hunter Street, Brunswick Square, London, the only child of John James Ruskin (1785–1864), a sherry importer, and Margaret Cox, formerly Cock (1781–1871), the daughter of a Croydon publican. His parents were first cousins: the intensity of the triangular relationship between father, mother, and son was to have both a creative and a destructive influence on the course of Ruskin's life. Contradiction governed a career driven by a search for synthesis.

Family background

Although the immediate social context of the Ruskin family was Edinburgh during the

commercially and intellectually flourishing period at the close of the eighteenth century, and these Scottish roots always remained important, the Ruskins were by origin English. John Ruskin's grandfather, John Thomas Ruskin (1761–1817), had moved to Edinburgh from London after an uncompleted apprenticeship to a vintner, and set up as a grocer, later giving himself the superior classification of 'merchant'. In Edinburgh in or about 1783 he married Catherine Tweddale, the daughter of a Presbyterian minister, who later brought an inheritance to the family. John Thomas was sometimes irascible and depressive, and not good at business, characteristics also to be found in his grandson. After John James Ruskin graduated from Edinburgh Royal High School in 1801 he was sent to London to find work as a clerk in a mercantile house rather than being allowed to study law as he had hoped.

John James Ruskin's future wife, Margaret, was the daughter of John Thomas's elder sister, who took over the management of a Croydon public house on her husband's death in 1787. At or about the time that John James Ruskin was sent to London, Margaret travelled north to become a companion to his mother, Catherine Ruskin.

Margaret adopted the firm religious principles of her aunt, and modified her surname to the more genteel Cox. In 1808 John Thomas failed in business, but his son shouldered the debt, so avoiding the slur of bankruptcy. In 1809 John James and Margaret became engaged, but the marriage was postponed because of John Thomas's debts and his opposition to the marriage. John Thomas moved to Perth with Catherine, and was cared for by Margaret, but his mental health deteriorated to the point of insanity.

John James, however, prospered in the sherry trade. In 1815 he became chief partner in the new firm of Ruskin, Telford, and Domecq, importing and distributing sherry and other wines. Domecq supplied the sherry from his vineyards near Jerez, Telford supplied the capital, and John James the salesmanship, effort, and acumen. In 1817 his mother suddenly died, and his father shortly afterwards, almost certainly a suicide. John James and Margaret were thus, after a nine-year engagement, free to marry, which they did, without celebration, early in 1818. The circumstances of their engagement, and the character of John James's parents, were to have an enduring effect in creating an atmosphere of duty, hard work,

and suppressed anxiety in the Ruskin household. While John James became increasingly wealthy and successful, his father's debts were not finally cleared until 1832.

Parental influence

In 1823 the Ruskin family moved from 54 Hunter Street (demolished 1969) and took a lease on a semi-detached house with a large garden at 28 Herne Hill, Herne Hill, Surrey (dem. *c*.1912). Ruskin was educated by his parents, with the help of private tutors, until the age of fourteen. The account of his childhood he gives in his unfinished and deliberately selective memoirs, *Praeterita* (1885–9), is far from trustworthy. On the one hand he suggests that it was paradisaical, but on the other that he was toyless and friendless. While *Praeterita* does reflect the close intensity of the atmosphere at Herne Hill, the isolation he describes is intended to explain his independence of mind, while the frustration and deprivation he evokes is more that of his old age than his of youth. He had plenty of toys and pets, including a dog that bit and scarred his lip for life. In 1828 he was joined from Perth by his cousin Mary Richardson, whose mother had died, and who remained

a member of the family until her marriage in 1848.

Ruskin's world was enclosed by his parents. From his father he learned his Romanticism: the tory medievalism of Walter Scott, the self-dramatization of Byron, and the nature worship of Wordsworth. From his mother he learned his religion. John James appears to have continued his own interrupted education alongside his son, resolving his intellectual frustration by investing in his offspring's creativity. He also passed on to him a love of drawing, having had a number of lessons when a youth from the Edinburgh landscape artist Alexander Nasmyth. From an early age Ruskin was encouraged both to draw and to write, and to take an interest in geology, beginning a handwritten mineralogical dictionary at the age of twelve. His early efforts at verse were generously rewarded by his father, at a farthing, later a halfpenny, a line.

This paternal literary and artistic encouragement was, however, tempered by maternal constraint, for the pleasures of imaginative expression were confined by a strongly evangelical self-discipline. As Helen Viljoen wrote:

whereas John James Ruskin reverently acqui-
esced to the articles of faith, Margaret partic-
ipated in Catherine's [her aunt, John James's
mother] doctrine with her *heart*, so that within
her own personality a religious creed became
emotionally, imaginatively, wedded to experi-
ence. Margaret's temperament was truly reli-
gious, as John James's was not. And it was this
temperament which Ruskin would share with
his mother—a temperament which largely
shaped his own experience of life and never
changed with creed. (Viljoen, 93)

Ruskin's certainty in the rightness of his views and
independence from received opinion—his critics
might say his dogmatism—is attributable to his
mother's cast of mind. Yet the conflict between
his father's expressive desire and his mother's cau-
tious restraint was to undermine his apparent con-
fidence throughout his life.

Ruskin was baptized at home on 20 February
1819 by a Presbyterian chaplain from the recently
founded Caledonian Chapel in Hatton Garden;
in south London the Ruskins attended the ser-
vices of an evangelical Congregationalist, Edward
Andrews, who was also Ruskin's first tutor. The

Ruskins, however, had become evangelical Angli-
cans by the time their son entered Christ Church,
Oxford, where he was confirmed into the Church
of England in April 1837, at the urging of his tutor,
the Revd W. L. Brown. Every morning, from the
age of three, his mother made him read from
the Bible and learn passages by heart. It was a
literary and intellectual as well as religious educa-
tion, for the sonorities of the King James Bible and
the eighteenth-century verse of the Scottish para-
phrases of the psalms were to inform his prose,
and the texts to supply a bedrock of reference
throughout his life. The evangelical interpreta-
tive practice of typology shaped his understanding
both of nature and of art, while the profound
appreciation that he gained of the wisdom of
Solomon from the Old Testament—later joined
by his reading of Plato—inclined him to be a law-
giver on his own account. The puritanism of his
religion was in conflict with the sensual appeal of
much of the art that he was to study, and inhibited
the enjoyment of his own body.

Ruskin's private education was enhanced by reg-
ular summer coaching tours, first to see the
picturesque scenery and visit the country house
collections of Britain, and then, from 1833

onwards, to see France, Switzerland, and Italy. Between 1833 and 1835 he spent his mornings at a day school run by the Revd Thomas Dale of St Matthew's Chapel, a Church of England establishment in Denmark Hill. In 1836 he attended lectures at King's College, London, where Dale had become the first professor of English literature. In October of that year he matriculated as a gentleman commoner at Christ Church, Oxford.

Ruskin was already a published author before going up to Oxford, with geological essays for J. C. Loudon's *Magazine of Natural History* in 1834. He published his first poetry in the *Spiritual Times* in August 1829 and contributed verses to the annual *Friendship's Offering* for the first time in 1835. At Oxford he wrote a series of essays linking architecture and nature for Loudon's *Architectural Magazine*, later republished as *The Poetry of Architecture* (pirate American edition 1873, authorized edition 1893).

The domestic intensity of Ruskin's early life developed, but was not the source of, a distinctive talent. He wrote in a draft for *Praeterita* that he had 'a sensual faculty of pleasure in sight, as far as I know unparalleled' (*Works*, 35.619). Ruskin's

perceptual sensibility, and his ability to deploy it both as a draughtsman and a visual analyst, marks him out from his more book-bound peers. He made only a few experiments in oil painting; his drawing skills were encouraged by a traditional drawing master, Charles Runciman, and refined by tutors of celebrity, Anthony Van Dyke Copley Fielding and then the more progressive James Duffield Harding. He continued to learn from contemporary artists until the 1860s. In 1873 he was elected an honorary member of the professional Old Watercolour Society, yet although his drawings would justify the appellation, he never considered himself an artist, emphasizing always that he drew in order to gain certain facts, and he exhibited rarely. None the less, Ruskin's drawings are a remarkable achievement, both as a record of his mind, and as works of great beauty. His ability visually to depict architecture and landscape was matched by his genius for the verbal description of works of art.

Ruskin's love of art was stimulated by his father's growing collection of works, chiefly by members of the Old Watercolour Society, through which Samuel Prout became a family friend. The most important artist to enjoy the Ruskins'

patronage was J. M. W. Turner. Father and son did not acquire their first watercolour by Turner until 1839, but Turner's work was well known to Ruskin from the vignette illustrations to the second edition of Samuel Rogers's poem *Italy*, published in 1830 and given to him for his thirteenth birthday in 1832. Ruskin produced imitations of both the illustrations and the travel verse. When Turner's new paintings in the 1836 Royal Academy summer exhibition were attacked in *Blackwood's Magazine*, Ruskin wrote a riposte intended for publication, but John James sent the piece to Turner, who did not wish the matter taken further.

Oxford

When Ruskin went into residence at Christ Church in January 1837 the grandson of a grocer and a publican stood on the threshold of the upper-middle class, with every prospect of becoming established in that social position by being ordained in the Church of England. His father's wealth and social aspiration meant that his enrolment as gentleman commoner gave him equal college status with members of the aristocracy. Yet he was not to be released from home,

for his mother moved into lodgings in the High Street, and his father joined them at weekends. Ruskin, by now 5 feet 10 inches tall, slimly built, with brown hair and striking blue eyes, was delicate, and prone to bouts of depression, so that his health was to break down, but it is possible that his mother was at Oxford to keep an eye on his spiritual as much as his physical health. The university was in the grip of the controversies surrounding the Oxford Movement; however, Ruskin showed no sign of being touched by high-church fervour, apart from becoming a member of the mildly ecclesiological Oxford Society for the Preservation of Gothic Architecture.

Unlike his aristocratic companions, Ruskin was a 'reading man', making him unpopular with some, but he made important friendships with the future classical archaeologist Charles Newton, and with Henry Acland, who was to play a key role in his lifelong relations with the university. He was encouraged by a young senior member of Christ Church, Henry Liddell, who was also to influence his future Oxford career. Though reading classical Greats, Ruskin attracted the attention of the geologist and natural theologian Dr William Buckland, and made drawings for his lectures. He

spoke at the Union, and put considerable effort into the Newdigate poetry competition, winning at the third attempt in 1839. He met Wordsworth when presented with the prize. Ruskin's poetic impulse was to fade in the 1840s, however, and he was not appreciative of his father's decision privately to publish a selection of his verse, *Poems*, in 1850.

In the autumn of 1839 Ruskin was advised to sit for an honours degree the following April, but the twenty-year-old was troubled by an adolescent passion for the daughter of his father's partner, Pedro Domecq. Adèle, a Roman Catholic partly educated in England, was the subject of Ruskin's youthful verse, but clearly not a prospect for marriage. In December 1839 he was devastated when he learned of her engagement, and was studying intensely for his examinations under a private tutor, the Revd Osborne Gordon, when in April 1840, shortly after Adèle's marriage, he coughed blood, and had to withdraw from the university.

Ruskin's academic and projected church career was blighted by this breakdown, but when after convalescence he sat for a pass degree in April 1842, he achieved the unusual distinction of an

honorary double fourth, taking his MA in October 1843. Ruskin deprecated his early Oxford career in *Praeterita*, but it is significant that he chose to publish the first two volumes of *Modern Painters* under the pseudonym 'a Graduate of Oxford'.

Art, architecture, and marriage

2

Ruskin's *Modern Painters*

Ruskin's initial hopes of returning to Oxford in the autumn of 1840 had been dashed by further slight haemorrhages, so his parents took him abroad, on a long continental tour from September 1840 to October 1841. The party travelled as far south as Naples, and spent two periods in Rome; Ruskin liked neither city. In Rome, however, he met Joseph Severn, the friend of Keats, whose son Arthur would marry Ruskin's cousin Joan Agnew and become his heir and unsympathetic guardian. Severn introduced Ruskin to a fellow painter, George Richmond, who became a firm family friend and made portraits of both Ruskins, father and son. Richmond, with his brother Tom, took the eager but naïve student in hand as regards the Italian old masters, and was to be regularly

15

consulted during the composition of *Modern Painters.*

At Oxford Ruskin's knowledge of Turner and the collection of his drawings had grown. He is believed to have first met the artist in June 1840, and Turner was soon on sufficiently good terms to accept the Ruskins' hospitality and attend birthday dinners in honour of their son. In 1842 father and son became patrons as well as collectors, when Turner's dealer Thomas Griffith included them in an invitation to Turner's circle of patrons to commission finished watercolours based on preliminary sketches. This opportunity, repeated in 1843, gave Ruskin a valuable insight into Turner's creative process, but his desire to acquire more drawings than his father would sanction became a matter of contention between them. Ruskin's own drawing style, partly under the influence of J. D. Harding, with whom he began lessons in 1841, was developing from the conventional picturesque in the manner of Prout towards a greater naturalism, a shift dramatized by two epiphanic moments in *Praeterita* (*Works*, 35.311, 314), the first describing drawing a piece of ivy at Herne Hill, the second an aspen at Fontainebleau, although there

is no independent evidence that they in fact occurred.

On returning to England in 1841 Ruskin spent six weeks at Leamington Spa, undergoing Dr Jephson's celebrated cure. In early summer 1842 the Ruskins once more went abroad, with Switzerland as their principal destination, returning via the Rhine. In Geneva Ruskin read an English newspaper review of that year's Royal Academy, attacking Turner's contributions. According to a letter to his former tutor Osborne Gordon, Ruskin 'determined to write a pamphlet and blow the critics out of the water' (*Works*, 3.666). This was the origin of *Modern Painters: their Superiority in the Art of Landscape Painting to the Ancient Masters*, a work in five volumes that would not be completed until 1860. The first two volumes were completed at the Ruskins' new home, 163 Denmark Hill (dem. 1947), a large detached house in 7 acres to which the family moved in the autumn of 1842, a mile from Herne Hill and overlooking Camberwell and Dulwich. Though dependent on his father's patronage, Ruskin was able to begin and sustain a career as a writer without any of the economic considerations that normally circumscribe literary life.

Ruskin's ruling theme in the first, unillustrated volume of *Modern Painters* was Turner's adherence to truth, but to a truth that extended beyond the mere factual appearance of landscape: 'There is a moral as well as material truth,—a truth of impression as well as of form,—of thought as well as of matter' (*Works*, 3.104). Such truths depended on a clarity of perception that was free of the pictorial conventions of the seventeenth-century Italian and Dutch masters who set the norm for received taste in landscape painting, and whose works were represented in Christ Church, the National Gallery, and Dulwich Picture Gallery. Ruskin substituted a different way of seeing, that of the geologist and botanist, deploying the accuracy of observation encouraged by the classificatory sciences that did not conflict with natural theology. Ruskin demonstrated his own ardent study of nature in the first volume of *Modern Painters*, and argued that Turner 'is the only painter who has ever drawn a mountain, or a stone' (ibid., 3.252).

The first edition, however, published in May 1843, stopped short of criticizing Turner's contemporaries, who worked in the convention of the picturesque. These were Ruskin's teachers, and his

father's friends. It was not until the third edition, published in 1846, also the year of the first publication of volume 2, that blame was substituted for praise. The tone and direction of volume 2 had been significantly influenced by Ruskin's visit to France, Switzerland, and Italy in 1845, the first time he had travelled on the continent without his parents. He had been able greatly to expand his knowledge of European painting by studying in the Musée du Louvre. In Pisa and Florence he began to examine early Italian painters such as Fra Angelico, the so-called 'primitives' who were beginning to attract scholarly attention thanks to Alexis Rio's *De la poésie chrétienne dans son principe, dans sa matière, et dans ses formes* (1836), which Ruskin read on the journey. After a recuperative break in the hills at Macugnaga and a visit to examine the site of Turner's drawing of the pass of Faido, which he had commissioned in 1843, he and Harding, who had joined him, travelled on to Venice. Not only did Ruskin, whose own drawing style was now a modified version of Turner's, begin to see through the conventional methods of his companion; in Venice he was confronted by the revelation of the true greatness of the Venetian masters, above all the paintings by Jacopo Tintoretto in the Scuola di San Rocco. It

was further evident to Ruskin that the city was suffering the effects of both modernization and decay.

The second volume of *Modern Painters* adopted a different style from that of the first. Ruskin wished to show that truthful perception of nature led to an experience of beauty that was also an apprehension of God. It was necessary to prove that beauty rested on an absolute, divine basis, not custom or subjective association. To this end he devised the concept of the 'theoretic faculty'—derived from the Greek *theoria*, or contemplation—a faculty which mediated between eye and mind, and which allowed an instinctual, emotional (in Ruskin's terminology, moral) as opposed to conscious and rational, apprehension of beauty: 'this, and this only, is the full comprehension and contemplation of the Beautiful as a gift of God' (*Works*, 4.47).

Ruskin divided beauty into two categories, 'vital' and 'typical'. Vital beauty, in accordance with natural theology, expresses God's purpose in the harmonious creation of the world and its creatures, including man. Typical beauty, in accordance with evangelical typology, expresses the immanence of

God in the natural world through the presence of 'types' to which man responds as beautiful. These types are qualities rather than things: infinity, unity, repose, purity, and symmetry. They are associated with divine qualities and can be found in nature and in art, but though abstract themselves, they have a real presence that it is the artist's duty truthfully to represent. Through his mother's training and the sermons he heard every Sunday, Ruskin had absorbed the evangelical practice of treating objects as both real and symbolic at the same time, a key critical practice that remained a feature of his writings throughout his life.

Ruskin completed the ground plan of his critical and aesthetic theories in volume 2 of *Modern Painters* with a discussion of the imagination. Where the theoretic faculty perceived, the imagination created. He posited three orders of truth: of fact, of thought, and of symbol, with their corresponding imaginative faculties. The penetrative imagination saw the object or idea, both its external form and its internal essence. The associative imagination enabled the artist or writer to convey the truth perceived and so his thought. The contemplative imagination turned these truths into symbolic form. Thus it

is perfectly legitimate for an artist to change or rearrange what he has truthfully observed and penetratively imagined, as Ruskin demonstrated in *Modern Painters*, volume 4 (1856), in his discussion of Turner's drawing of the pass of Faido (*Works*, 6.34–41). There was a higher truth than natural fact, but it took Ruskin until the completion of *Modern Painters* volume 5 (1860), via a discussion of the 'Symbolical Grotesque' in *The Stones of Venice*, volume 3 (1853), fully to develop a theory of the imagination that successfully synthesized the dialectic of the real and the symbolic.

The second volume of *Modern Painters* was published in April 1846 (and the third, revised edition of volume 1 in September). The defence of Turner was incomplete—indeed, he was little discussed in the volume—while the range of reference to Renaissance and pre-Renaissance artists is much wider. The critical reception of these first two volumes was mixed: there were approving remarks from Charlotte Brontë, Wordsworth, and Elizabeth Gaskell, but Ruskin's challenge to an aesthetic orthodoxy derived from Sir Joshua Reynolds and Sir George Beaumont drew strong disapproval from the Revd John Eagles in *Blackwood's*

(54, October 1843, 485–503) and from George Darley in *The Athenaeum* (3 and 10 February 1844).

Venice and *The Stones of Venice*

None the less, Ruskin was launched on a literary and intellectual career: he was invited to the breakfasts of Richard Monckton-Milnes and Samuel Rogers, while to his father's table came a conservative mixture of artists, collectors, and evangelical clergymen. During 1847 he experienced a period of depression and uncertainty, and took another cure with Dr Jephson of Leamingon. His mind was turning towards architecture. The visit to Italy in 1845 had made him aware of the beauty and decay of Italian Romanesque and Gothic. The Gothic revival, and its Romanist tendencies, was also attracting his interest. In 1844 Ruskin had been involved with the architect Gilbert Scott's rebuilding of a local church, St Giles, Camberwell, in the Gothic revival style. He and a friend made at Thomas Dale's school, Edmund Oldfield, who was to join Ruskin in helping to found the Arundel Society in 1849, designed the painted glass for the east window. In 1853 Scott also consulted Ruskin about

remodelling the Camden Chapel (damaged by fire 1907, destroyed *c*.1940) in Romanesque style. On a visit to Venice during the now almost ritual family tour in the summer of 1846 Ruskin read Robert Willis's *Remarks on the Architecture of the Middle Ages, especially of Italy* (1835), and continued the development of the more analytical style of architectural drawing that he had begun in 1845.

Ruskin published two lengthy review articles in the *Quarterly Review*: on Lord Lindsay's *Sketches of the History of Christian Art* (81/159, June 1847, 1–57)—in which he discussed architecture as well as art for the first time—and Sir Charles Eastlake's *Materials for a History of Oil Painting* (82/164, March 1848, 390–427). He now concentrated on architectural research, visiting Salisbury Cathedral in July 1848 before making a tour of the churches of Normandy from August to October. Ruskin had married Euphemia Chalmers Gray (1828–1897), usually known as Effie, on 10 April 1848; northern France was as far as they could travel that year, because of the political disturbances in France, and the Venetian revolt against Austrian occupation and the ensuing siege of the city.

The Seven Lamps of Architecture was published in May 1849, the first of Ruskin's works to carry his name, and the first to be illustrated, with fourteen plates drawn and etched by him. A reference in the preface to the depredations of 'the Restorer, or Revolutionist' (*Works*, 8.3n) made Ruskin's position clear. He wished to protect what survived, and draw from it certain principles which would influence the direction of the Gothic revival, notably towards the use of Gothic in secular buildings. His purpose was both to secularize and make protestant the movement, drawing it away from the Roman Catholic influence of Augustus Welby Pugin. His intervention was theoretical rather than practical: the 'lamps' of architecture were moral categories—sacrifice, truth, power, beauty, life, memory, and obedience. Like the types of typical beauty in *Modern Painters*, volume 2, they are abstract notions in themselves, but for Ruskin were manifested in particular Gothic buildings in Italy and northern France.

The timeliness of Ruskin's intervention, and his growing reputation, meant that the book received considerable, if mixed, attention; his moral purpose was appreciated but his technical knowledge was questioned. *The Seven Lamps of Architecture*,

however, proved only the prelude to a much larger work, *The Stones of Venice* (3 vols., 1851–3), which had a political as well as an aesthetic dynamic. Ruskin's opening remark in *Praeterita* carries an important, if exaggerated, truth: 'I am, and my father was before me, a violent Tory of the old school' (*Works*, 35.13). Although John James Ruskin's commercial interests made him a free-trader, he belonged to the ultra-tory school of thought which had not been reconciled to Catholic emancipation or the Reform Act of 1832. The ultra-tories had strong links to the evangelicals, several of whose preachers were friends of the Ruskin family. The first volume of *The Stones of Venice* was published against the background of the 'papal aggression' crisis of 1850, when the Roman Catholic church restored the Catholic episcopal hierarchy in England. Ruskin's admiration for Venice in part stemmed from its traditional resistance to the authority of Rome, and in his opening sentences he drew political as well as moral and cultural parallels between the lost maritime empires of Tyre and Venice, and the threatened empire of England:

Since first the dominion of men was asserted over the ocean, three thrones, of mark beyond

all others, have been set upon its sands: the thrones of Tyre, Venice, and England. Of the First of these great powers only the memory remains; of the Second, the ruin; the Third, which inherits their greatness, if it forget their example, may be led through prouder eminence to less pitied destruction. (ibid., 9.17)

The three volumes of *The Stones of Venice* were the product of the most concentrated period of study in Ruskin's life, including two long winters spent in Venice, from November 1849 to March 1850, and September 1851 to the end of June 1852. On both occasions Ruskin was accompanied by his wife, Effie, who the first winter also had a companion, Charlotte Ker. The siege of 1849 had ended only three months before, and the Ruskin party staying at the Hotel Danieli must have been some of the first foreign visitors. The winter was arduous, but Ruskin threw himself into a systematic study of Venetian architecture. He explained in the first volume:

> To my consternation, I found that the Venetian antiquaries were not agreed within a century as to the date of the building of the facade of the Ducal Palace, and that nothing was

known of any other civil edifice of the early
city ... Every date in question was determinable
only by internal evidence; and it became nec
essary for me to examine not only every one
of the older palaces, stone by stone, but every
fragment throughout the city which afforded
any clue to the formation of its styles. (*Works*
9.3–4)

Ruskin set about establishing, by drawing and
measurement, an architectural typology that
would account for the evolution of Venetian
Gothic from the Romanesque, and also reveal
within the Gothic itself the first signs of the deca-
dence that overtook the city's architecture as it
turned to Renaissance forms. This typology, while
conforming to the archetypal trope of rise, efflor-
escence, decline, and fall, was considered still
largely valid 150 years later. The first volume
of *The Stones of Venice*, *The Foundations*, written
in the intervening summer and winter of 1850–
51, and published in March 1851, was taken up
principally with a theoretical discussion of the
elements of architectural construction and decora-
tion, as a prelude to a cultural study of Venice itself
in the following two volumes. It was illustrated
with woodcuts and engravings, and supported

by a folio-sized part-publication: *Examples of the Architecture of Venice*. The technical prose was as ill received as the technical examples. The first volume sold slowly while the folio publication, intended to run to a dozen parts, was halted after the issue of only three (one in May and two in November 1851), with fifteen plates published.

When Ruskin and his wife returned to Venice in 1851 economic life had revived, and the young and attractive Mrs Ruskin much enjoyed the social life afforded by the Austrian military authorities in Venice and Verona. The Ruskins rented a set of rooms in the Casa Wetzler on the Grand Canal (which became the Gritti Palace Hotel). Ruskin continued his research, placing more emphasis on archival work, where he was much helped by an English resident, the antiquarian Rawdon Brown, whom the Ruskins had first met in December 1849. (While Ruskin had adequate French, his Italian was always limited.) Ruskin was drafting parts of the second volume, and it is evident both from the manuscript and from his correspondence with his father that he was under parental pressure to adopt a more elevated and less technical style.

One solution to the problem of Ruskin's excessive production of text, already adopted in volume 1 was to thrust unwieldy or technical material into appendices. In the case of volume 1, one appendix was expelled from the book altogether and was issued on 6 March 1851 as *Notes on the Construction of Sheepfolds*, an evangelical intervention on the proper relation between clergy and laity which argued that the true church consisted of both, and called upon all Church of England (and Church of Scotland) factions to unite in resistance to Rome. Ruskin partly acknowledged the difficulties of volume 1 in 1879 when he issued a travellers' edition which compressed the whole work into two volumes (vol. 2, 1881) and omitted most of the first volume. Ruskin also regretted in later life the strongly protestant tone of the work.

Although equally encumbered with appendices, volume 2, *The Sea-Stories* (issued July 1853), and volume 3, *The Fall* (issued October 1853), benefited from John James Ruskin's editorial intervention. Ruskin traced the history of Venice from its origins among the late Roman refugees on Torcello, describing this as the 'Byzantine Period' which lasted until the 'Serrar del Consiglio' at

the beginning of the fourteenth century, when the Venetian oligarchy was established, and of which St Mark's was the key building. The Gothic period, of which the ducal palace formed the focus, closing volume 2, lasted until the mid-fifteenth century. Ruskin could be polemically exact when situating the ensuing decline: 'I date the commencement of the Fall of Venice from the death of Carlo Zeno, 8th May 1418' (*Works*, 9.21), but this date was subject to revision, and while criticizing the decline of architecture which began with the corruption of the Gothic itself, Ruskin expressed his admiration for painters of the Renaissance such as Tintoretto, Bellini, Titian, Giorgione, and Veronese. The third volume, divided between 'Early Renaissance', 'Roman Renaissance', and 'Grotesque Renaissance', traced 'the moral temper of the falling Venetians...from pride to infidelity, and from infidelity to the unscrupulous *pursuit of pleasure*' (ibid., 11.135). Ruskin was prepared to acknowledge the qualities of the classical, sixteenth-century Casa Grimani by Michele Sanmicheli, but not that of Andrea Palladio's San Giorgio Maggiore, completed in 1610, which he found 'gross...barbarous...childish...servile... insipid...contemptible' (ibid., 11.381).

The importance of *The Stones of Venice* lies not in its hostility to the Renaissance, but in its celebration of the Byzantine and the Gothic, which had an immediate effect on Victorian architects, who began to introduce Romanesque forms and Venetian and Veronese colour and sculptural features into their designs. Ruskin's reputation was such that, unusually, *The Times* devoted three long review articles to the second and third volumes. Ruskin's dialectical argument by contrasts was a technique possibly borrowed from Pugin, whom Ruskin affected not to have read, but certainly knew. The contrast between an English cathedral close and St Mark's Square, for example, supports the fundamental contrast Ruskin draws between the fates of the Venetian and British empires (*Works*, 10.78–84).

The 'critical medievalism' of Thomas Carlyle's *Past and Present* also contributed to Ruskin's world view, Ruskin having met Carlyle for the first time in 1850, and he was thus drawn into the beginnings of his social and economic criticism, where Carlyle remained an influence and a support. In the chapter 'The nature of Gothic' (*Works*, 10.180–269) Ruskin argued that under conditions of industrialization and the division of labour,

social disharmony and industrial unrest were bound to occur, because the previously expressive craftsman—Ruskin's ideal working man—had been reduced to the condition of a machine:

> the great cry that rises from all our manufacturing cities, louder than their furnace blast, is all in very deed for this—that we manufacture everything there except men; we blanch cotton, and strengthen steel, and refine sugar, and shape pottery; but to brighten, to strengthen, to refine, or to form a single living spirit, never enters into our estimate of advantages. (ibid., 10.196)

Such a view was not inconsistent with Ruskin's toryism, for his ideal society, represented by the creative, harmonious, noble, and imperialist Venice of the fifteenth century that he imagined, was one of hierarchy and order, rights and responsibilities, privileges and duties. But it is significant that this chapter was twice separately reprinted in his lifetime, first for the inauguration of the London Working Men's College in 1854, and second by William Morris in 1892. In his introduction to the Kelmscott edition Morris wrote: 'To some of us when we first read it, now

many years ago, it seemed to point out a new road on which the world should travel' (*Works*, 10.460).

Ruskin's marriage

On 25 April 1854 Ruskin accompanied his wife to King's Cross railway station to see her off on a visit to her parents in Scotland. He was about to make another continental journey, with his own parents, but without her. That evening Ruskin was served with a legal citation at Denmark Hill, claiming the nullity of the marriage. Following an undefended hearing in the ecclesiastical commissary court of Surrey on 15 July 1854, the marriage was annulled on the grounds that 'the said John Ruskin was incapable of consummating the same by reason of incurable impotency' (Lutyens, *Millais*, 230). Ruskin was in Chamonix with his parents on the day of the hearing.

There is little that is certain about the intimate details of Ruskin's marriage to Euphemia Chalmers Gray beyond the fact that it was never consummated. A medical examination confirmed Effie's virginity, but in a legal deposition that was not introduced in court, Ruskin stated: 'I can prove my virility at once' (Lutyens, *Millais*, 192).

This was never put to the test, but it seems likely that Ruskin was referring to masturbation. Again, there is no confirmation of this, but a letter to a confidante, Mrs Cowper, in 1868 in which he wrote 'Have I not often told you that I was another Rousseau?' (*Letters…to Lord and Lady Mount-Temple*, 167) has been taken as a discreet reference to the practice. At this same time he told a male friend that he had been capable of consummating his marriage, but that he had not loved Effie sufficiently to want to do so (Burd, *John Ruskin*, 115).

Effie was the daughter of a Perth lawyer, George Gray. A family friend and business associate of John James Ruskin, in 1829 Gray had moved into the former Ruskin family home, Bowerswell, Perth, the scene of John Thomas Ruskin's probable suicide, although the house was rebuilt in 1842. Effie first met her future husband when she was twelve, on a visit to Herne Hill. The following year, 1841, on a second visit, she challenged him to write a fairy story. This became Ruskin's only published work of fiction, and one of his most popular books, when *The King of the Golden River* was published in 1850 with illustrations by Richard Doyle. The tale, in the manner of the brothers

Grimm, deployed imagery that was to resurface in Ruskin's writings on political economy.

It took Ruskin a time to recover from his infatuation with Adèle Domecq. In 1846 he began to show an interest in Charlotte Lockhart, granddaughter of Sir Walter Scott, and daughter of James Lockhart, editor of the *Quarterly Review*. This tentative attraction, however, was transferred to Effie, who came to stay at Denmark Hill at the time of her nineteenth birthday in May 1847. Ruskin, as has been seen, was suffering from nervousness and depression at this time, but after another cure with Dr Jephson he travelled to Scotland to visit a new friend, William Macdonald, at Crossmount. The journey provided an opportunity for courtship when he called on the Grays at Perth in October, where he decided he was in love. Ruskin did not propose to Effie, however, until he had returned to London, and both offer and acceptance were by letter.

Ruskin's parents raised no objections to the union, possibly fearing a repetition of the breakdown that followed Adèle Domecq's marriage, but preparations for the wedding in the following year were marred by Gray's near bankruptcy as a result of

railway speculation. So there was no dowry, while
Ruskin himself became anxious at the prospect
before him.

The wedding took place at Bowerswell on 10
April 1848, but neither John James nor Margaret
Ruskin was present, being uncomfortable with
the associations of the house. The first night was
spent at Blair Atholl. In a letter to her father
in 1854, revealing the extent of the marriage's
failure, Effie said that she had been sexually igno-
rant and that Ruskin 'was disgusted with my
person the first evening' (Lutyens, *Millais*, 156).
This has been interpreted as meaning that Ruskin
was equally innocent, especially in the matter of
female pubic hair, but this seems unlikely, as he
had seen erotic images belonging to fellow under-
graduates at Oxford. There is also speculation that
Effie's menstrual cycle interfered with consum-
mation (Hilton, *John Ruskin: the Early Years*, 119),
which is plausible but not provable.

It is evident that innocence, combined with anx-
iety, together with a mutual desire to travel
without the encumbrance of pregnancy, led to
an agreed postponement—according to Effie,
until her twenty-fifth birthday. Outwardly the

newlyweds became a fashionable and cultivated young couple, returning from their honeymoon to live at Denmark Hill, before the eleven-week summer tour of Normandy. On their return they moved into a rented house at 31 Park Street, Mayfair, although Ruskin, who was working on *The Seven Lamps of Architecture*, continued to use his study at Denmark Hill. In France, Effie had witnessed Ruskin's self-absorption, and there was already friction with his parents which became serious at new year 1849 when she fell ill. In February 1849 she returned to her parents and did not see her husband for nine months, while he took his parents to Switzerland in the summer. In Scotland she consulted a gynaecologist, while her father tried by letter to prise her husband from his parents. In September Ruskin somewhat reluctantly travelled north to collect her. Three weeks later they set out for Venice.

The two long stays in Venice of 1849–50 and 1851–2 appear to have been the happiest for the couple, for Effie was able to enjoy Austro-Venetian society, and Ruskin was able to work, while the senior Ruskins were at a distance. Ruskin began to experience religious doubt while on the second visit to Venice, writing a long commentary, now

lost, on the book of Job; but this was kept from his public writings. In the intervening sixteen months they continued to live at Park Street, and Ruskin to work at Denmark Hill. During this period their social and intellectual circle continued to widen. They were on calling terms with Sir Charles Eastlake, president of the Royal Academy and director of the National Gallery, and his wife, Elizabeth. While Ruskin disapproved of Sir Charles's taste, Lady Eastlake formed an alliance with Effie. Through friendship with F. J. Furnivall, Ruskin came into contact with the Christian socialist F. D. Maurice. Ruskin was also friendly with the poet Coventry Patmore, and it was through Patmore that he became acquainted with the Pre-Raphaelite circle, notably John Everett Millais.

During his second winter in Venice in 1852 Ruskin tried unsuccessfully to persuade the National Gallery to buy paintings by Tintoretto. The Ruskins' Venetian stay ended in scandal and inconvenience after the theft of Effie's jewels. An Englishman attached to the Austrian army was suspected, their departure was delayed, and Ruskin had to decline a challenge to a duel. The case remained unsolved. In June 1852 they returned, not to Park Street, but to a new address,

30 Herne Hill (dem. 1912), which John James Ruskin had leased and furnished at his own expense, and to his own taste. It was now clear to Effie that Ruskin did not intend to consummate the marriage, and she felt trapped by the close proximity of Ruskin's parents, who were increasingly critical of her alleged extravagance. She spent seven weeks with her own parents at Bowerswell from September 1852, and told them of her unhappiness, though not the full reasons for it.

In the spring of 1853 Ruskin rented a house at 6 Charles Street, Mayfair, for a few weeks at the start of the London season, apparently to satisfy Effie's taste for London society. They were together at the private view of the Royal Academy summer exhibition in May, where Millais was showing *The Order of Release, 1746*, for which Effie had posed as the freed Jacobite prisoner's wife. Ruskin, who saw himself as Millais's mentor and champion, repeated an invitation, first made to Millais in 1851, to holiday with him, this time not in the Alps, but in Scotland. Through the artist John Frederick Lewis, whom Ruskin also patronized, he had been invited to lecture at the Philosophical Institution in Edinburgh that autumn,

a first public appearance on the lecture platform that alarmed his parents. The holiday party was intended to include Millais's brother William, and the artist Holman Hunt. Hunt however declined, as he was preparing to go to the Holy Land.

In June Ruskin's party travelled north, visiting the house of the intellectual, amateur scientist, and antiquarian Sir Walter Trevelyan at Wallington in Northumberland. Ruskin had known the cultivated Pauline, Lady Trevelyan, since 1847, and they enjoyed a close friendship until her death, while travelling abroad with her husband in Ruskin's company, in 1866. At the beginning of July they arrived at the hamlet of Brig o'Turk, Glenfinlas, near Stirling, staying first at a hotel, and then in a rented cottage, where Millais and Effie were thrown much together, and fell in love. A project to paint Effie's portrait at the castle of Doune was abandoned (although oil sketches of her and many drawings were produced) and Ruskin's portrait was commissioned instead, a full-length posed in the bed of a rocky stream. Ruskin was preparing the index to *The Stones of Venice* and writing his Edinburgh lectures, for which Millais helped to draw large diagrammatic illustrations.

In November, the portrait still unfinished, the party broke up at Edinburgh as Ruskin gave his lectures. Effie went to Bowerswell, and Millais to London. After the Ruskins returned to London in late December he continued to pose for Millais so that the head and figure could be put into the portrait, which was not finally completed and paid for until December 1854, after Millais had made a second trip to the site in June. Ruskin did not break with Millais until then. His marriage, however, had effectively ended in the autumn of 1853. Effie had given up any pretence of being able to get on with Ruskin's parents; Millais had written to Effie's mother attacking Ruskin. For Ruskin what followed was a convenient way out of a failed relationship. On 7 March Effie finally wrote to her father telling him the truth about her marriage. Lawyers were consulted, and on 25 April Effie left Ruskin for good. She married Millais on 3 July 1855.

'Be assured I shall neither be subdued, nor materially changed, by this matter. The worst of it for *me* has long been passed' (*Works*, 36.165). This comment in a letter to F. J. Furnivall, of 24 April 1854, demonstrates not only that the difficulties of Ruskin's marriage were already the subject of

gossip before the rupture, but that he was deter-
mined to ignore them as far as possible. It is ironic
that the scandal should have broken just as he was
becoming a public figure, and it is indicative of his
determination that during the 1850s Ruskin estab-
lished himself as a contemporary art critic, with a
commitment to social as well as aesthetic reform.
This is demonstrated by his support for the Pre-
Raphaelite painters, the London Working Men's
College, and the University Museum, Oxford—all
interlocking projects. It was only when he came to
complete his defence of Turner at the end of the
decade that doubt, even despair, broke in.

Critic of contemporary art

3

Ruskin and the Pre-Raphaelites

Turner, Gothic architecture, and the Pre-Raphaelites were the topics of Ruskin's four Edinburgh lectures of 1853, published the following year in revised form as *Lectures on Architecture and Painting*. A writer for the *Edinburgh Guardian* recorded this impression of Ruskin's first public appearance as a lecturer:

Mr Ruskin has light sand-coloured hair; his face is more red than pale; the mouth well cut, with a good deal of decision in its curve, though somewhat wanting in sustained dignity and strength; an aquiline nose; his forehead by no means broad or massive, but the brows full and well bound together; the eye we could not see . . . Mr Ruskin's elocution is peculiar; he has

a difficulty in sounding the letter 'r'; but it is not this we now refer to, it is the peculiar tone in the rising and falling of his voice at measured intervals, in a way scarcely ever heard except in the public lection of the service appointed to be read in churches. These are the two things with which, perhaps, you are most surprised,— his dress and his manner of speaking,—both of which (the white waistcoat notwithstanding) are eminently clerical. (*Works*, 12.xxxi–xxxii)

The only feature missing from this description apart from Ruskin's distinctive eyes is the light blue cravat that became his personal emblem.

Ruskin's association with the Pre-Raphaelites was complicated by the public and private agendas of the personalities involved. He was doubly powerful, being a private patron (and adviser to other buyers such as the Trevelyans, Lady Waterford, Ellen Heaton, and Francis McCracken) as well as being a public critic. There was self-interest on both sides: Ruskin sought friendship while expecting an affirmative response to his critical views; the artists had their careers to serve. In a letter to Tennyson in 1857 Ruskin referred to himself in terms of 'we PRBs' (*Works*, 36.265),

he was a member of the Hogarth Club (1858–61), and he helped with the organization of a Pre-Raphaelite exhibition at Russell Place. But his decade in seniority made him more patron than brother-in-arms and his break with Millais divided an already fissiparous group of artists. His initial influence was indirect, but his emphasis on rejecting conventional picture making, accurate observation of nature, and the symbolic possibilities of natural fact were part of the Pre-Raphaelite programme. Holman Hunt read the second volume of *Modern Painters* in 1847 and drew Millais's attention to the writer's ideas. A reading of *The Stones of Venice* by William Morris and Edward Burne-Jones when Oxford undergraduates in 1853 was similarly significant. But Ruskin had not appreciated Millais's *Christ in the House of his Parents* with its high-church iconography when he saw it at the Royal Academy in 1850. Architecture and Venice were his principal preoccupations at the time of the Pre-Raphaelite Brotherhood's most cohesive activity.

When the Pre-Raphaelite paintings in the 1851 Royal Academy were again critically assaulted, Millais decided to make an appeal to Ruskin through their mutual acquaintance Coventry

Patmore. Ruskin may also have been more directly engaged, for his father expressed an interest in buying Millais's *The Return of the Dove to the Ark*. The result of Patmore's appeal was two letters from Ruskin to *The Times* on 13 and 30 May 1851, defending works by Millais, Holman Hunt, and Charles Collins, though by no means over-praising them, and warning against their Tractarian tendencies. The personal friendship with Millais followed, and Ruskin's decision to promote and try to mould the young artist.

The public expression of this came in additions to *Modern Painters* and the pamphlet *Pre-Raphaelitism*, issued in August 1851. The title may appear opportunistic, for the principal subject was Turner, and the most important statements about the Pre-Raphaelites were relegated to a footnote. Yet Ruskin understood the potential of the movement and its radical intentions: 'the Pre-Raphaelites imitate no pictures: they paint from nature only' (*Works*, 12.357n). In Millais he saw a successor to the ageing Turner, as another, though stylistically different, seeker of visual and imaginative truth. (The programme of Millais's Glenfinlas painting was the intended synthesis of a Turnerian landscape subject with Pre-Raphaelite

attention to detail in a contemporary portrait.) Arguing always that the Pre-Raphaelites represented only a first step, he welcomed them as potential founders of 'a new and noble school in England' (ibid., 12.358n).

Ruskin had come to appreciate the extent to which Millais was not Turner by the time his portrait was complete and their friendship became impossible, though Ruskin was still ready, as late as 1886, to recognize aspects of his talent (*Works*, 14.495–6). In 1854 Ruskin again wrote twice to *The Times*, this time on the subject of Holman Hunt's Royal Academy pictures *The Light of the World* (5 May) and *The Awakening Conscience* (25 May). Hunt was away in the Holy Land, and as Hunt was a close associate of Millais at this time, Ruskin's friendship with the most 'Ruskinian' of the Pre-Raphaelites did not develop until after 1869. Instead Ruskin turned his enthusiasm to Dante Gabriel Rossetti, a very different kind of painter and a very different personality, whose work he had first seen in 1853. He bought and commissioned drawings from Rossetti, and from his future wife, the ailing Elizabeth Siddal. He sought medical help for her from his friend Henry Acland, now established with a medical practice

and an academic career at Oxford, and in 1855 made her an allowance of £150 a year, an arrangement that appears to have ended in 1857. He guaranteed Rossetti an income from purchases, and in 1858 advanced £100 towards the publication of the artist's *Early Italian Poets* (1861). He encouraged commissions from his American friend Charles Eliot Norton and from the Leeds collector Ellen Heaton.

Although Rossetti took advantage of Ruskin's patronage, his bohemian ways did not conform to his patron's values, and from 1857 onwards the friendship began to cool. Rossetti resented Ruskin's scoldings, while Ruskin found Rossetti's Romantic medievalism increasingly morbid. In 1862 when, following Siddal's death, Rossetti moved to 16 Cheyne Walk, Ruskin tentatively suggested that he too might take rooms there, but the idea came to nothing. There was a dispute over the circulation of a joint portrait photograph, with William Bell Scott, taken at the house in 1863. By 1865 the increasingly quarrelsome Rossetti was falsely accusing Ruskin of selling his drawings, and Ruskin, now out of sympathy with the turn the artist's work had taken, ended their connection. He did, however, pay tribute to Rossetti in

his lectures *The Art of England* (1883) after the
artist's death in 1882.

Although no longer obliged to 'go into society',
Ruskin sought intellectual companionship with
writers as well as artists. In 1853 he met the Edin-
burgh physician and Turnerian Dr John Brown
for the first time, although their correspondence
ran from 1846 until 1882. In 1854 he met the
public health reformer Dr John Simon, who
became a close friend and nursed him after his
first mental breakdown. In 1855 he first met
the Bostonian Charles Eliot Norton, who was to
promote Ruskin's ideas in America and become
his literary executor and, with Joan Severn, the
burner of much material relating to Rose La
Touche. Ruskin regularly visited Thomas Carlyle
at this period, who introduced him to the hist-
orian J. A. Froude. Ruskin was a visitor to Mrs
Henry Prinsep's salon at Little Holland House,
the home of George Frederick Watts who had
made a portrait drawing of Effie Ruskin, and
who was also to be celebrated in *The Art of
England*. Tennyson was also a frequenter of the
salon. Coventry Patmore introduced Ruskin to his
fellow poet William Allingham and to Robert and
Elizabeth Browning during their visit to England

in 1855, with whom an important friendship developed.

Teaching and Turner

A supporter of the Architectural Museum since 1851, at the end of 1854 Ruskin became involved in two parallel projects, the University Museum, Oxford, and the London Working Men's College, neither initiated by him, but providing opportunities for participation and patronage. The University Museum had been promoted by Acland, and once Ruskin had met the architect, Benjamin Woodward, he became closely involved in not only raising funds for the decoration of the building, but in the decorative scheme itself, proposing designs and encouraging the employment of Pre-Raphaelite artists such as the sculptors Alexander Munro and Thomas Woolner. He had hoped that Rossetti would also undertake work there, but instead Rossetti chose to lead the decoration of the new Oxford Union library and debating hall, also designed by Woodward. As a secular building devoted to the natural sciences, the University Museum was a contemporary expression of Ruskin's views on Gothic architecture; he carried his aesthetic principles into the social sphere by

lecturing to the craftsmen who were building it.

Woodward's tuberculosis threw increasing respon-
sibility onto Acland and Ruskin; when Woodward
died in 1861 the decorative scheme, though not
the building, was still incomplete, and Ruskin lost
interest in the project.

Ruskin's connection with the London Working
Men's College lasted somewhat longer, although
he was most active between 1854 and 1858, when
he gave regular classes. The college had been
founded by a group of Christian socialists, with
F. D. Maurice as principal. Ruskin's political views
did not conform to its founder's: he said his aim
was 'directed not to making a carpenter an artist,
but to making him happier as a carpenter' (*Works*,
13.553). But he was pleased to conduct an ele-
mentary drawing class where his emphasis on
shading and on sketching from natural objects was
in contrast to the methods instilled in the govern-
ment schools of design, of which he was becoming
increasingly critical. He recruited Rossetti to teach
a class in figure-drawing and painting. It was
through the college that Edward Jones (later
Burne-Jones) met Rossetti in early 1856, at the
same time as he came into contact with Ruskin,

the beginning of a third Pre-Raphaelite friendship.

Ruskin taught drawing, largely by letter, to private correspondents as well as at the Working Men's College. Among these at various times were Louisa, marchioness of Waterford, Ellen Heaton, Louise Blandy (the daughter of his dentist), Ada Dundas, and the artists Anne Mutrie, Anna Blunden, and Isabella Jay. Octavia Hill, who was to run a philanthropic housing scheme with Ruskin's support in the 1860s before falling out with him, first met him as a pupil. It was his reputation as a teacher that led to the fatal introduction to the La Touche family in 1858. In 1859 he became an unofficial patron and teacher at Margaret Bell's progressive school for girls at Winnington in Cheshire. His teaching methods were synthesized in *The Elements of Drawing* (1857) in which he argued that: 'the sight is a more important thing than the drawing' (*Works*, 15.13). He followed this popular riposte to contemporary drawing manuals with the far less successful *Elements of Perspective* in 1859 and wrote again on drawing in the uncompleted *Laws of Fiesole* in 1879. Ruskin's opposition to the mechanical methodology of the government schools led him

to found his own school of drawing at Oxford when he began to lecture as the first Slade professor in 1870.

Besides allowing Ruskin to develop his teaching principles in practice, the London Working Men's College was the recruiting-ground for a number of Ruskin's assistants, most notably his future publisher, George Allen. William Ward was to be employed by him to facsimile Turners, J. W. Bunney to record threatened architecture, Arthur Burgess to assist with work at Oxford, and Henry Swan to become curator of the Museum of the Guild of St George.

Between 1855 and 1859 Ruskin was also engaged in the annual production of his *Academy Notes*—brief and highly selective notices of paintings that had caught his eye in the Royal Academy summer exhibition, the Watercolour societies, the Society of British Artists, and the French exhibition. These pamphlets were rapidly produced and went through changing editions; they were idiosyncratic, but attempted to steer the middle-class buyer through the dense patchwork of paintings and drawings displayed. He praised works which in his view conformed to Pre-Raphaelite

aspirations as he understood them, within a broadly realist aesthetic. He also criticized those whom he supported, notably J. F. Lewis, and John Brett, whose *Val d'Aosta* (1859) had been painted virtually to Ruskin's instructions but which none the less was pronounced a disappointment (though he subsequently bought the picture). Other artists, among them Alfred William Hunt and J. C. Hook, received important encouragement. Ruskin abandoned the series in 1859, partly because of the low standards that year, partly for more general reasons of disenchantment with the art market, but he issued one more number devoted to the Royal Academy of 1875.

Ruskin's active engagement in so many different aspects of the contemporary art world helped to delay the completion of *Modern Painters*, although there were other contributory factors. The death of Turner, with whom he had never had an easy relationship, at the end of 1851 presented difficulties, for now the entire contents of his studio were open to inspection. Ruskin, perhaps also projecting some of his own experience onto the artist, began to discover a darker message in his work. Faced with the entanglements of Turner's will, he quickly resigned as an executor

(an appointment to be taken as an acknowledgement of his service to the artist). When the legacy of paintings and drawings was released to the National Gallery in 1856, however, he campaigned to be allowed to make a representative selection of watercolours from the 20,000 works on paper. Once given permission in 1857, Ruskin placed 400 in cabinets of his own design, thus making them available for public inspection in the National Gallery. In 1856 he also contributed the letterpress to the dealer Ernest Gambart's publication of Turner mezzotints, *The Harbours of England*. Work on the Turner bequest—cleaning, mounting, and framing as well as cataloguing—continued until May 1858. He published a commentary on the oil paintings placed on display at Marlborough House in January 1857, and followed this with a privately printed selection of works on paper for the trustees of the National Gallery. He then published a further catalogue of works on paper arranged for display at Marlborough House (1857, rev. edn 1858). He completed his arduous task with a printed report to the trustees in 1858. Among the many sketchbooks and drawings were discovered a number which both Ruskin and the National Gallery authorities deemed to be obscene. Fearing that possession of such

drawings might be illegal, the keeper, Ralph Wornum, proposed their destruction. Ruskin and the authorities agreed, and he witnessed the burning although he ensured that a small number of sketchbooks were preserved.

The third volume of *Modern Painters* appeared in January 1856, the fourth in April, but the final volume was not published until June 1860. The natural world was still Ruskin's touchstone, and Turner still his artist-hero, but both were seen in an altered context as Ruskin tried to come to terms with the waning of his dogmatic evangelical belief and the correlative loss of a spontaneous joy in landscape. His critical yardstick was still an artist or writer's fidelity to truth, 'but truth so presented that it will need the help of the imagination to make it real' (*Works*, 5.185). Taken as a whole, these volumes constituted an attempt to establish a satisfactory theory of the imagination that rested on the material facts of the natural world, but which showed not only that these facts also carried a profound symbolic truth, but that that truth could equally be conveyed in symbolic form. The crowded symbolism in Holman Hunt's minutely realistic *The Awakening Conscience* and the entirely imaginary, though equally

realistically depicted, image of Christ in Hunt's *The Light of the World* must serve here as short-hand examples.

As Ruskin developed his theories from the notion of the 'grotesque' in *The Stones of Venice* his interest in the symbolic meanings contained in both art and literature became central. Devising the term 'the pathetic fallacy' (*Works*, 5.201), he rejected Romantic notions of a personal identification between the artist and the external world, but increasingly he saw the artist as a seer-mediator between God and man. Fallen man is necessarily a flawed lens, but Ruskin discovered a tragic nobility in this state. As he began to adopt a more humanistic approach, conscious of his own falli-bility and even sensuality, he developed a system of mythographic interpretation, assisted by Max Müller's philology, which drew both on Judaeo-Christian and Hellenic traditions. These myths existed in nature, and in the contemporary world. They were also susceptible to a psychological reading, as expressions of the moral conflicts in the mind of man.

Turner was finally presented as the interpreter of these myths, attesting both to the spiritual

condition of the artist, and of the nineteenth century. Ruskin wrote of *The Garden of the Hesperides* (1806):

> Such then is our English painter's first great religious picture; and exponent of our English faith. A sad-coloured work not executed in Angelico's white and gold; nor in Perugino's crimson and azure; but in a sulphurous hue, as relating to a paradise of smoke. That power, it appears, on the hill-top, is our British Madonna. (*Works*, 7.407–8)

The dragon crouched above the garden is also the serpent in the Christian paradise, and a symbol of the moral and industrial pollution of Britain.

Ruskin's mid-life crisis

> Once I could speak joyfully about beautiful things, thinking to be understood;—now I cannot any more; for it seems to me that no one regards them. Wherever I look or travel in England or abroad, I see that men, wherever they can reach, destroy all beauty. (*Works*, 7.422–3)

This comment towards the close of volume 5 of *Modern Painters* is evidence of the gloomier state

of mind in which the great project of the first
half of Ruskin's life was completed, and shows
the direction that his thoughts were taking in
his fortieth year. It has been customary to treat
1860 as a watershed, with the publication of four
essays on political economy in the *Cornhill Mag-
azine* as a new beginning. But the change of sub-
ject matter—already suggested in *The Nature of
Gothic*—had been adumbrated in 1857, and the
relationship between the aesthetic economy and
the moral climate remained a pivotal issue. 1860
is the central point of a process lasting several
years on either side of that date. The key ele-
ments were a change in religious position, a new
view of the Italian masters of the Renaissance,
increasingly strained relations with his parents,
and the stirrings of sexual desire. During this
process Ruskin once more experienced depression
and uncertainty. In a letter to Elizabeth Barrett
Browning in November 1860 he wrote: 'I am
divided in thought between many things, and the
strength I have to spend on any seems to me
nothing' (ibid., 36.350).

As early as 1851 Ruskin had begun to see that
the natural theology that sustained his evangelical
Romanticism was threatened by the advances of

science and biblical criticism. He privately confessed to Acland:

> If only the Geologists would let me alone, I could do very well, but those dreadful Hammers! I hear the clink of them at the end of every cadence of the Bible verses—and on the other side, these unhappy, blinking Puseyisms; men trying to do right, and losing their very Humanity. (*Works*, 36.115)

His initial response to doubt was to suppress it by an act of faith, but in the summer of 1858 he travelled to Switzerland and Italy alone, in order to recuperate from his intense and disturbing work on the Turner bequest. He stayed for six weeks in Turin, spent enjoyable nights at the opera, and for the first time broke his strict sabbatarianism by drawing on a Sunday. He worshipped with the local protestant Waldensian community, but was struck by the contrast between the narrow plainness of the services and their setting, and the visual splendour of Veronese's *Solomon and the Queen of Sheba* which he was studying in the Turin municipal gallery. In later accounts he described the change of heart that followed as an epiphanic moment that left him 'a conclusively *un*-converted man' (ibid., 29.89). That day, he

later wrote in his autobiography, 'my evangelical beliefs were put away, to be debated of no more' (ibid., 35.496).

While we may accept Ruskin's account as an 'un-conversion', it is clear that this was not a sudden event, nor was it a change to outright atheism, though for a time Ruskin lost faith in the hope of an afterlife. His fundamentally religious cast of mind remained the same, and it is significant that for some years after their first meeting in 1857 a favourite opponent in private religious debate was the evangelical Baptist Charles Haddon Spurgeon. The Bible remained a sacred text, but its wisdom now formed part of a wider literature of divine inspiration.

Ruskin's relaxation of his previously narrow religious views had an important relation to the change in his ideas on art and artists. Indeed, each is a consequence of the other. The emphasis was now less on the pure and spiritual than on the human and the physical. A note written during his work in the Turin gallery, and shared with his father, read: 'A good, stout, self-commanding, magnificent Animality is the make for poets and artists' (*Works*, 7.xl). This view

was arrived at through the knowledge gained from the Turner bequest, but also from the study of Giorgione, Veronese, and Titian, who with Turner became the principal figures in *Modern Painters*, volume 5. This turn towards the Venetian colourists of the sixteenth century, as opposed to the painters of the preceding Gothic period, had a broader significance. His interest in the Gothic revival waned at this period, and he became critical of the Romantic medievalism of Rossetti and his circle. At the same time his belief in the continuity of the highest tradition in Western art, derived from classical antiquity, pointed not only forward to the founding principles of the Pre-Raphaelites, but back to the Greeks themselves.

The young artist Edward Burne-Jones, imbued though he was with a morbid medievalism, was a beneficiary of Ruskin's 'Venetian' period. He had first corresponded with Ruskin in January 1856, and then came into regular contact through the London Working Men's College and Little Holland House, gradually replacing Rossetti in Ruskin's affections. In 1859 Burne-Jones travelled in Italy at Ruskin's expense, studying the artists of whom his patron approved. Ruskin commissioned

and bought work from him, and in 1861 became godfather to the artist's son Philip. In 1862 he and his wife, Georgiana, again travelled in Italy, at Ruskin's expense and for some of the time in his company, patron and artist both making copies of Ruskin's latest 'discovery', the early sixteenth-century Lombard painter Bernardino Luini. Burne-Jones became a frequenter of Winnington Hall School, making designs for a tapestry to be embroidered there for Ruskin, but never completed. In 1863 Ruskin commissioned him to make designs intended for the published version of his second series of essays in political economy, *Munera pulveris* (1872). During the 1860s Ruskin enjoyed a happy relationship with Burne-Jones, who seemed the contemporary artist most in sympathy with the classical and mythological bent of his current writings; but there was a falling-out, never quite repaired, in 1871. Burne-Jones had become a devotee of Michelangelo, whose violent mannerism Ruskin attacked in his lecture *The Relation of Michael Angelo to Tintoret* (1872), to Burne-Jones's anger.

At first, until Georgiana Burne-Jones succeeded in charming him, John James Ruskin disapproved of his son's favour for the artist—another bone

of contention, along with the family's collection of Turners, between father and son. It is significant that in March 1861 Ruskin gave forty-eight Turner drawings from his collection to the Ashmolean Museum, Oxford, and a further twenty-five to the Fitzwilliam Museum, Cambridge, in May—a gesture of personal divestment as much as of public generosity. John James, feeling his age and in declining health, put heavy moral pressure on his son to complete *Modern Painters*. In 1859 parents and child made their last continental journey together, visiting Cologne, Berlin, Dresden, and Munich so that Ruskin could make good his deficient knowledge of their galleries, and make further studies of Veronese and Titian. It was not a happy tour, and Ruskin's religious views no longer accorded with his mother's fiercely held beliefs. To make matters worse, in September 1860 she broke her thigh, while his father's health began to trouble him.

Characteristically, Ruskin responded to domestic and other difficulties by proposing to withdraw into private research. In February 1861 he spoke of this in a letter to Charles Eliot Norton, describing:

almost unendurable solitude in my own home, only made more painful to me by parental love which did not and never could help me, and which was cruelly hurtful without knowing it; and terrible discoveries in the course of such investigation as I made into grounds of old faith. (*Works*, 36.356)

He certainly withdrew from his parents' company. From 1859 until 1868 he regularly sought recreation and refuge at Winnington Hall School, John James disapproving of his financial support for Miss Bell. He was also much abroad, for he had a long-term project to write a history of Swiss towns, an idea that produced many drawings, but no text.

Ruskin spent much of the summer of 1861 at Boulogne, and was in Switzerland until Christmas; from May to November 1862 he was in Italy, Switzerland, and then across the border in Savoy, returning to Mornex in Savoy in December where he had rented a house and installed his assistant George Allen with an etching press. After a visit to England in the summer of 1863 he returned to Chamonix. All this time he was contemplating exile, telling Norton in 1862: 'I must find a home'

(*Works*, 36.407). To that end in 1863 he seriously considered buying land in order to build a house high on the Brezon above Bonneville in the Savoy Alps. He was dissuaded from this impracticality, but he did buy land at Chamonix, subsequently disposed of. In November 1863 he returned to England, but remained as peripatetic as ever, his wanderings only brought to an end by the final illness of his father, who died on 3 March 1864.

Public education and personal tragedy

The political economy of art

Ruskin's inheritance was £157,000, pictures worth at least £10,000, and property in the form of houses and land. He immediately began to disperse this fortune in charitable and philanthropic schemes—notably placing Octavia Hill in charge of some of his houses—but made the unfortunate choice of the fraudulent artistic entrepreneur Charles Augustus Howell as secretary and almoner, although he had seen through him by 1869. He remained tied to his mother (aged eighty-three in 1864), living at Denmark Hill, but the burden was eased by the arrival of his young second cousin once removed Joan (Joanna) Agnew, who became his mother's companion. In death, as in life, John James's money allowed his son to live and write as he wished,

but the concomitant parental censorship was removed. Ruskin's epitaph on his father's tomb— 'He was an entirely honest merchant' (*Works* 17.lxxvii)—had an unconscious irony, for it was a merchant's money that allowed Ruskin to devote the latter half of his life to a critique of the creation and distribution of wealth, and an attempt, by word and deed, to enforce its redefinition.

Ruskin's engagement with political economy came through art and architecture, as *The Nature of Gothic* had shown. In 1857 the great Manchester Art Treasures Exhibition gave him an opportunity to make a more direct intervention, when he was invited to give two lectures which he half-satirically entitled *The Political Economy of Art* (1857, reprinted, with additions, as *A Joy for Ever*, 1880). Just as his pamphlet of 1854, *The Opening of the Crystal Palace*, used the re-erection of the Crystal Palace at Sydenham to plead for the preservation of old buildings, Ruskin's Manchester lectures subverted the display of masterpieces by speaking of art in economic terms. Like further lectures in Manchester and Bradford reprinted as *The Two Paths* (1859), they were concerned with

issues of production and distribution within the aesthetic sphere. What linked them to political economy was a labour theory of value derived from Adam Smith and David Ricardo; for artists, like Gothic craftsmen, were workers, creating the pictorial wealth celebrated by the Manchester exhibition.

Although Ruskin's criticism of orthodox utilitarian economics became increasingly direct as he moved from the field of cultural production on to the manufacturers' home ground, he repeated a trope of his writings on art and architecture by casting himself as an outsider, claiming, in this case quite rightly, to have little theoretical knowledge of economics. It was this independent position that gave him his sense of moral authority, although it means that Ruskin's political economy must be distilled from a wide range of writings on both art and society. In Manchester, the home of *laissez-faire*, he stated: 'the "Let-alone" principle is, in all things which man has to do with, the principle of death' (*Works*, 16.26). The word 'death' was not a rhetorical flourish. Throughout his economic writings and social commentary it bore the full weight of Ruskin's absolute distinction between good and evil. The countervailing

image was life, as in his celebrated statement in *Unto this Last* (1862): 'THERE IS NO WEALTH BUT LIFE' (ibid., 17.105). Wealth was expressed, not by the economist's value in exchange, but the moralist's value in use.

The principle that governed the creation and distribution of wealth was both aesthetic and political: 'Government and co-operation are in all things and eternally the laws of life. Anarchy and competition, eternally, and in all things, the laws of death.' This 'Law of Help', appeared twice in Ruskin's writing. In *Modern Painters*, volume 5, it was applied to principles of composition (*Works*, 7.207), whereas in *Unto this Last* it was applied to economic relations (ibid., 17.75). In spite of the socialist-sounding reference to co-operation, Ruskin's anti-capitalism was profoundly conservative. His admiration for the Venetian republic and his own upbringing reinforced a strict, if benevolent, paternalism that rested on notions of an implacable divine justice rather than a calculated equity. This conception of justice lay behind his active support for Thomas Carlyle and other fellow members of the Governor Eyre Defence and Aid Fund in 1865–6, in opposition to the Jamaica Committee led by John Stuart Mill, as his

speech on the Jamaica insurrection showed (ibid., 18.552–4).

Ruskin's first two attempts to convey his moral principles in political economic terms initially were failures, much derided in the establishment press, but they laid the foundations for the creation of a much wider constituency for Ruskin's ideas that was to keep his values in circulation even when he himself had fallen silent. The first of these was the articles published in the *Cornhill* in 1860, an outlet deliberately chosen because of its middle-class appeal. To the editor Thackeray's embarrassment, Ruskin's attack on the utilitarian *homo economicus* caused an outcry that led to the series being abbreviated, although Ruskin was allowed more space for his fourth and final contribution. The articles were reprinted, without significant alteration, as *Unto this Last* in 1862, and at first sold very badly. A further four articles, this time for Froude in *Fraser's Magazine* in 1862–3, attempted to build on the new definitions offered in *Unto this Last* and were also stopped. They were not published in volume form until 1872, as *Munera pulveris*, dedicated to Carlyle. Ruskin's persistence in attacking the conventional business ethics of his day

inevitably exacerbated tension with his merchant father.

Lectures and letters

From Ruskin's Manchester lectures of 1857, his confidence as a lecturer grew, for he relished the direct contact with an audience, the opportunity to extemporize, and the persuasive effect the immediacy of his presence and delivery had. Such lectures and addresses could then be gathered up, revised, and issued in volume form, and throughout the 1860s this was his method of publication. These lectures should be read as a continuous and developing discourse, rather than as closed studies of fixed subjects. They were critiques both of contemporary culture and of the society that produced that culture. In the two lectures, 'Of kings' treasuries' and 'Of queens' gardens', delivered in Manchester in 1864, and reprinted as *Sesame and Lilies* (1865; with a third lecture, 'The mystery of life and its arts', 1871), Ruskin evoked images of kingship and queenship, which in their respective public and domestic spheres offered male leadership and female care, an ideal of moral and social responsibility in contrast to the selfish anarchy of *laissez-faire*. He

pursued similar themes in the three lively and contentious lectures republished as *The Crown of Wild Olive* in 1866 (issued with a fourth lecture and other matter, 1873).

In 1867 Ruskin experimented with another form of public yet personal discourse which he was to use increasingly frequently—the letter to a newspaper. In this case the letters were addressed, not to an editor, but to Thomas Dixon, a cork-cutter in Sunderland who arranged for their republication in the *Leeds Mercury* and the *Manchester Examiner*. The letters, ranging freely over the issues of the day, and particularly the agitation for reform, were reprinted as *Time and Tide, by Weare and Tyne: Twenty-five Letters to a Working-man of Sunderland on the Laws of Work* in 1867. Their form anticipated that of *Fors Clavigera* from 1871 onwards.

A leading theme developing throughout Ruskin's writings of the 1860s was the importance of education. This too grew out of his earlier art criticism, since it was his intention to educate both artist and patron; but the issue broadened to the purpose and methods of education in general. At Winnington Hall School his informal teaching in person and

by letter extended far beyond that of a drawing master. In 1866 he again experimented with discursive form by dramatizing himself in the persona of the 'Old Lecturer (of incalculable age)' (*Works*, 18.207), in a series of Socratic dialogues with a dozen girls modelled on his favourite pupils at Winnington: *The Ethics of the Dust*. Here crystallography is deployed as the ruling metaphor in lectures that are part games, part moral lessons, and which convey the pleasure he took in his young audience's company.

Ruskin did not neglect more straightforward issues of art criticism, though his lectures and articles no longer respected any boundary between the categories of aesthetics, literature, philosophy, political economy, or natural science. He published a series of nine articles in the *Art Journal* in 1865–6 under the general title 'The Cestus of Aglaia', gave the lecture 'Modern art' at the British Institution in 1867, and gave the Rede lecture at Cambridge, 'The relation of national ethics to national arts', the same year, on the occasion of receiving an honorary doctorate from the university. (He was to receive an honorary doctorate in civil law from Oxford in 1893.) He gave the lecture 'The flamboyant architecture of the valley of

the Somme' in 1869 at the British Institution and arranged an exhibition of paintings and drawings by himself and others in illustration. He adopted a similar procedure the following year, after an extended visit to Verona for the Arundel Society, in 1869, with his lecture 'Verona and its rivers', in which he advocated extensive damming to control the flood waters of the Alps.

The most significant of this group of works was published in 1869 as *The Queen of the Air*, three 'lectures' on the Greek myths of Athena assembled from various sources, including material from his *Art Journal* articles. Deploying philology, botany, colour theory, economics, and moral philosophy as well as his distinctive form of mythography, Ruskin presented a modern myth of Athena, an emblematic figure who stood for the healing and creative powers of the imagination, and of nature. Her counter-type was the serpent, a symbol of pollution, whose coils might be found in drains, or in the wreaths of black smoke that darkened the sky and drew obscurity over the lecture he gave in Dublin in 1868, 'The mystery of life and its arts'. The female principle represented by Athena had particular personal significance for Ruskin, and it is necessary to turn to the events in his private

life that overshadowed all his public work of the 1860s, and beyond.

Rose La Touche

In January 1858 Ruskin called for the first time at the London residence of Mr and Mrs John La Touche, as a result of an introduction effected by Louisa, marchioness of Waterford. John La Touche was a wealthy Irish banker of Huguenot extraction, who had a large estate at Harristown, co. Kildare. He was a follower of Charles Haddon Spurgeon, by whom he was to be baptized as an evangelical Baptist in 1863. Maria La Touche did not share her husband's evangelicalism, had published two novels, and was a member of an aristocratic circle of cultivated Anglo-Irishwomen. It was the La Touche habit to spend a Christmas and spring season in London, which accounted for the pattern of journeys between Harristown and London in the following years. Mrs La Touche wished to lionize Ruskin, and did so by asking him to give drawing lessons to her daughters Emily (1844–1867) and Rose (1848–1875). Ruskin at first demurred, but a friendship began. It was thus just after her tenth birthday, on 3 January 1858, and just before his thirty-ninth on 8 February, that

the tragic relationship between Rose and Ruskin
began.

Initially Ruskin appears to have been interested equally in Mrs La Touche and her daughters. Mrs La Touche began as one more of Ruskin's married confidantes, and it was during a visit to Harristown in August 1861 that he told her of his changed religious position. She asked him not to make this public for ten years. By the autumn of 1861 Ruskin felt deeply drawn towards Rose, but that October she fell ill for the first time from the psychosomatic disorder (possibly the as yet unrecognized condition *anorexia nervosa*) which eventually killed her. Rose was strongly under her father's religious influence, and published a volume of devotional poetry, *Clouds and Light*, in 1870. Ruskin's preference for daughter over mother may have caused some tension, and Ruskin was out of sympathy with the father, so that his continental wanderings from 1862 to 1864 were partly driven by a desire to avoid their London visits. He did not see Rose between the spring of 1862 and December 1865, though Mrs La Touche did not break off contact. Rose had further bouts of illness in 1862 and 1863.

Like other men of his class and culture—for instance, his future Oxford colleague Charles Dodgson—Ruskin enjoyed the company of young girls, as his happiness at Winnington testified. It was their purity that attracted him; any sexual feelings were sublimated in the playful relationship of master and pupil that characterized his letters to several female correspondents. These flirtations continued in parallel to his more profound feelings for Rose. In 1887, after his mental health had broken down more than once, a tutelary friendship with a young art student, Kathleen Olander, developed into a fantasy of marriage on his part, before her parents intervened. It is possible to see a sad reprise of the relationship with Rose in this final passion.

Rose was no flirtation. Just after her eighteenth birthday in January 1866, with Ruskin about to turn forty-seven, he proposed marriage. Her answer was not a refusal, but a request to wait for three years. The La Touches became alarmed by the love that was apparent on both sides, but did not entirely sever communications. Ruskin was forced to rely on intermediaries, the first of whom was Georgiana Cowper, *née* Tollemache. He had seen her in Rome in 1840, and met her again in

1854. In 1848 she had married William Cowper, a stepson of Lord Palmerston, who acknowledged this patrimony by changing his name to Cowper-Temple in 1869, becoming Lord Mount-Temple in 1880. In 1865 he had inherited Palmerston's estate, Broadlands in Hampshire. The second intermediary was George MacDonald, a friend of Mrs La Touche who had been forced by his unorthodox views to give up holy orders and become a writer. The third was Joan Agnew, only two years older than Rose, who between August 1866 and September 1867 was engaged to the La Touches' son Percy (1846–1921), and who was sometimes allowed to see Rose when Ruskin was not.

Ruskin endured the waiting. In May 1868, at a time when there had been reassuring letters from her, there was an opportunity to see Rose in Dublin, where he had travelled to give his lecture 'The mystery of life and its arts'. But there was no meeting, and communications became expressly forbidden. The reason was that Mrs La Touche had consulted Ruskin's former wife, Effie, about his character and about her view of the legal position. The fear was that a consummated marriage with Rose would render the previous grounds for

annulment void, and so make the second marriage bigamous. The three years' wait passed, and Rose's bouts of illness continued. It was not until 7 January 1870 that Ruskin met her accidentally at the Royal Academy. Covert communication was resumed and Rose assured him of her love, though alluding to the religious obstacles between them, for Ruskin's position had been known to her since 1862, and her own religious devotion was extreme.

In October 1870 Mrs La Touche showed Rose the results of further correspondence with Effie Millais, which had the desired damaging effect. Ruskin for his own part sought legal advice which concluded that a marriage was possible, and communicated this to Rose in the summer of 1871. She however rejected him. Both Rose and Ruskin became ill, he experiencing a physical and mental breakdown at Matlock Bath in Derbyshire in July. In 1872 Rose initiated a reconciliation through MacDonald and the Cowper-Temples which brought an initially reluctant Ruskin hurrying back from Venice at the end of July. There were a few days of happiness, but Ruskin pressed his case for marriage and Rose refused. In 1873, by which time Rose's condition was deteriorating, it was Ruskin's turn to reject a possible meeting. At

the beginning of 1874, estranged from her parents, Rose travelled to London in search of medical treatment. Joan Agnew was allowed to see her, but Ruskin not. In September, when she was again in London, her parents relented, and Ruskin was able to visit her regularly until her return to Ireland in December. In January 1875 she was back in London, but extremely ill, and Ruskin saw her for the last time on 15 February, before she was taken to Dublin in April. She died on 25 May, aged twenty-seven. Ruskin heard the news on 28 May. He was broken-hearted.

The role played by religion in this tragedy was cruelly ironic, for Ruskin's abandonment of his evangelical beliefs in the very year that he had first met Rose had proved an insurmountable obstacle. Yet Rose, through those associated with her, was to help restore Ruskin's faith. Mrs Cowper and her husband were devotees of the spiritualist movement. Persuaded by her, Ruskin attended his first séance in February 1864 and in April had several séances with the American medium Daniel Dunglass Home, who impressed him. He saw Home again in July 1866, and through the Cowpers maintained an interest in spiritualist manifestations of the afterlife. In March 1868, however,

he attended a séance with the Cowpers that disillusioned him with the charlatanism associated with mediums, and he abandoned the practice, but not his interest.

In March 1874 Ruskin left England for Italy, where he had been asked to supervise the making of copies of frescoes by Giotto in the church of St Francis in Assisi for the Arundel Society. He visited Rome, where he made a study of Botticelli's *Zipporah* in the Sistine Chapel, travelled to Naples, and then crossed to Sicily. He returned to Rome and in early June settled at Assisi until the end of July, when he moved on to Lucca, and Florence. Here he prepared the guidebook *Mornings in Florence* (1875–7) before returning to England at the end of October, via Chamonix.

In Assisi Ruskin made use of the sacristan's cell and engaged in religious disputes with the friars, while continuing private Bible reading. His chief interest was not the frescoes in the upper church being copied for the Arundel Society, but works in the lower church that he attributed to Cimabue and Giotto. He made a careful study of *The Marriage of Poverty and St Francis*, where the roses above Poverty's head provoked

home thoughts from abroad. His study of pre-Renaissance painters continued in Florence, and brought about a shift in his appreciation that recognized the spiritual as distinct from the technical achievement of their work. It also produced a shift in his religious views, back to a renewed sense of faith that was to make his work 'much more distinctly Christian in its tone' (*Works*, 29.86).

Grief at the death of Rose La Touche in 1875 left him once more open to the attractions of spiritualism. In December 1875 he went to stay with the Cowper-Temples at Broadlands, where a medium convinced him that she had seen Rose in communication with him, although he himself saw and heard nothing. He was thus predisposed to believe in the possibility of receiving some sign from Rose when the following year he spent the winter in Venice, making a close study of Carpaccio's cycle of paintings on the life of St Ursula in the Accademia Gallery. Permitted to have *The Dream of St Ursula* in a private room, as the anniversary of the Broadlands 'teachings' approached, Ruskin increasingly identified Rose with the dead virgin saint. At Christmas a series of coincidences, including reading a letter from

Mrs La Touche to Joan Severn, convinced him that Rose was in communication with him, and that he should be reconciled with her mother. In a state of exaltation, he became a ' "Catholic" ', though 'no more ... a *Roman*-Catholic, than again an Evangelical-Protestant' (*Works*, 29.92).

Oxford and Brantwood

The Slade professor

The private distress caused by the seventeen-year relationship with Rose La Touche undermined Ruskin's mental stability: there are many coded references to her in his public writings. None the less, by the end of the 1860s Ruskin was established as a prominent, if controversial, commentator on art and social issues, with a growing following. His position received institutional recognition when he was elected Oxford's first Slade professor of fine art in August 1869. The election was engineered by Henry Acland. In 1858 Ruskin had been made an honorary student (that is to say, fellow) of Christ Church; Acland had promoted his candidacy for the professorship of poetry in 1866, and in 1867 suggested he became a curator of the University Galleries (now the Ashmolean Museum).

The Slade professorship came at a domestically eventful time for Ruskin: in April 1871 his mother's companion, Joan Agnew, married Arthur Severn, and moved into the former Ruskin home at 28 Herne Hill. His old nurse, Anne Strachan, died. During that summer he bought, unseen, the small house at Brantwood, across the lake from the then Lancashire village of Coniston, from the radical pamphleteer William Linton. On 5 December his mother died, so he was free to give up the house at Denmark Hill, and to begin to enlarge and improve Brantwood, into which he formally moved in September 1872. Having been made an honorary fellow of Corpus Christi College in April 1871, he began to divide his time, when not travelling on his familiar paths abroad, between his rooms in Corpus, Brantwood, and Herne Hill, where he occupied his former nursery.

Ruskin's activities in the 1870s attempted to synthesize his intentions and beliefs. The teaching at Oxford ran in parallel with a wider mission of social reform, addressed to the world at large through the medium of his monthly publication, begun in January 1871, *Fors Clavigera: Letters to the Workmen and Labourers of Great Britain*. Significantly, he recast his relationship with his

audience by taking over his publishing activities from Smith, Elder & Co., and placing them in the hands of his assistant George Allen. Allen became not only responsible for *Fors Clavigera*, but in 1871 began to publish an accumulative edition of Ruskin's works which presented him in terms of his later social writing, rather than the 'fine' writing of before 1860. Ruskin's insistence on a fixed retail price for his books was to lead in time to the establishment of the net book agreement, which lasted until the 1990s. By 1873 Ruskin was in full control of his publishing activities, and released a stream of publications, usually in part form, across the field of natural science, cultural history, political economy, and art criticism. The thrust of his writing, however, was to try to extend his arguments into practical action. None of these projects achieved more than partial success, yet they stood as examples of what might be aspired to: as always with Ruskin, the parts represented a greater whole.

Ruskin's initial appointment as Slade professor was for three years at a salary of £360 a year—the only money he ever earned, apart from the sale of his books. This was renewed twice before his first resignation in 1878. He gave eleven series

of lectures during this period. Most were subsequently published, although the printed versions do not fully reflect the liveliness, humour, and sometimes anger of their delivery, nor the effect of the varied and ingenious illustrations and demonstrations that accompanied them. Many had to be delivered twice because of their popularity. The printed versions do, however, indicate the free range of his mind. After the controlled and helpfully didactic inaugural *Lectures on Art* (1870, delivered February and March 1870), they cover the whole spread of Ruskin's interests. The chief series were *Aratra Pentelici: Six Lectures on Sculpture* (1872, delivered November and December 1870); *Lectures on Landscape* (1897, delivered January and February 1871); *The Eagle's Nest: Ten Lectures on the Relation of Natural Science to Art* (1872, delivered February and March 1872); *Ariadne Florentina: Six Lectures on Wood and Metal Engraving* (1876, delivered November and December 1872); *Love's Meinie: Lectures on Greek and English Birds* (1881, delivered March and May 1873, published together with two given at Eton College); *Val d'Arno: Ten Lectures on ... Tuscan Art* (1874, delivered October and November 1873); *Deucalion* (1879, geological essays, including four lectures delivered in October and November 1874,

and to which are related the botanical studies published as *Proserpina*, issued in parts between 1875 and 1886). Ruskin's course 'Twelve studies in the *Discourses* of Sir Joshua Reynolds', delivered in November 1875, and his 'Twelve readings in *Modern Painters*', delivered in November and December 1878, were not published. He took leave of absence in Venice in the winter of 1876–7.

Ruskin's principal intention was to instruct Oxford undergraduates in their responsibilities as future leaders, and as patrons of art. He carried his polemic into the practical field by in 1871 taking over the existing government-sponsored Oxford School of Art in the University Galleries and reconstituting it as a drawing school, to be run according to his own principles and administered by a drawing-master (the school's existing incumbent, Alexander MacDonald) whose post he endowed with £5000. He accumulated a collection of visual aids, drawn from his lectures, which he developed in successive catalogues for use as a course of instruction. The materials included his own drawings, works by Turner from his original gift of 1861, to which he added more, works by artists he patronized and assistants he employed, engravings, woodcuts, and photographs, and even

pages from an illuminated missal, for it was ever Ruskin's habit to cut up and distribute parts of the medieval manuscripts he collected throughout his life. These materials were framed and housed in mahogany cabinets of his own design, arranged in three principal series: the 'Standard and reference' series, holding 200 frames, and the 'Rudimentary' and 'Educational' series, holding 300 frames each. These valuable collections (which were in a constant state of rearrangement), together with plaster casts, books, and other works of art, were kept in the gallery used by the drawing school, and formally given to the university in 1875.

Ruskin's many other projects, however, and his absences from Oxford, meant that the Ruskin School of Drawing did not function as he would have wished. Indeed, Ruskin began to feel a certain disenchantment with Oxford, both in his relations with the senior members, who envied his reputation and did not respond to his calls for reform, and with the undergraduates, who in the main sustained a hearty philistinism. In March 1874, as an antidote to rowing and cricket, he called for volunteers to help drain and surface a muddy track in the nearby village of Ferry Hinksey. This project, which ended the following

summer, attracted public ridicule, but proved to
be a valuable recruiting ground for a new genera-
tion of followers, among them Arnold Toynbee,
H. D. Rawnsley (with Octavia Hill a future founder
of the National Trust, Ruskinian in inspiration),
his future editor and literary executor Alexander
Wedderburn, and his devoted interpreter and first
biographer, William Gershom Collingwood.

Reform and the Guild of St George

The notion of healthy labour was a direct link
to the principles enunciated in *Fors Clavigera*,
its title a play on the notion of fortune as key
or fateful hammer. The pamphlet's serendipitous
theme allowed Ruskin, by pricking the conscience
of the world, to justify his private pleasure in
art and collecting. The free form enabled him
to address public and private events, while the
response of his correspondents engendered a vir-
tual dialogue with his audience. His work for the
Mansion House committee for the relief of Paris
during the Franco-Prussian War was an early
topic.

Through the pages of *Fors Clavigera* Ruskin was
able to develop the idea of a utopian society, or

treasure-store, initially launched in 1871 as the St George's Fund with £7000 of his own money. It would hold land, promote education, and eschew industrial life and the steam engine. A first gift of houses in Barmouth, north Wales, was made in 1875 by an admirer, Mrs Fanny Talbot, and other gifts and supporters were found through *Fors Clavigera*. In its legal and constitutional form, the Guild of St George did not come into existence until 1878, or meet until 1879. Ruskin was appointed master, with absolute authority over a strictly hierarchical order of society that reflected his ideal image of Venice. The guild acquired little land and built no schools, nor was its membership ever large; yet it served as a focus for Ruskin's most earnest disciples, and remains the one direct link with his ideas.

The most practical expression of the guild's values was a museum, placed in a cottage in the Walkley district of Sheffield. The property was bought in November 1875 at the instigation of a former pupil of the London Working Men's College, Henry Swan, who had gathered a group of working men interested in launching a collective farming experiment at nearby Totley—again paid for by Ruskin. The museum was

multiform and multipurpose, serving as a library and teaching collection including casts, drawings, prints, and geological specimens. When in 1876 Ruskin became alarmed by the destructive restoration of buildings in Venice and elsewhere, it became the repository of the copies and studies he commissioned from a small group of English and Italian copyists regularly employed by him. The crowded cottage was extended in 1884, and in 1890 the collection moved to a house provided by Sheffield corporation at Meersbrook Park, by which time Ruskin was no longer actively in control of his affairs.

Ruskin continued the monthly production of *Fors Clavigera* even when abroad, and regular publication was maintained until letter 87 of March 1878, when Ruskin had his first complete mental collapse. His themes and moods were many, but there was an ever-stronger note of reiteration, as autobiographical material began to appear more frequently. Matter from *Fors Clavigera* was drafted into *Praeterita*, begun in January 1885. Another sign of reiteration was his increasing use of baby talk in his private letters to Joan Severn. In 1875 he asserted the values of an earlier form of transport by commissioning a new posting carriage.

In 1876, tired of Oxford and grieving for Rose La
Touche, Ruskin returned to Venice for the first
extended stay since 1853. His intention was to
revise *The Stones of Venice* (another turning back),
possibly adding a fourth volume. Distracted, how-
ever, by his many projects and his obsession
with the St Ursula–Rose connection, he produced
another guidebook, *St Mark's Rest* (1877–84), a
*Guide to the Principal Pictures in the Academy of
Fine Arts at Venice* (1877), and contributed the
preface to a book by a Venetian curator, Count
Alvise Zorzi, that protested against the proposed
restoration of the façade of St Mark's. Ruskin car-
ried this campaign to England and used the Guild
of St George as a conduit for support, commis-
sioning a large painting of the façade from his
copyist J. W. Bunney. These protests proved suc-
cessful and the proposed restoration was stopped.

After his return to England at the end of May
1878 Ruskin delivered his extempore 'Readings
in *Modern Painters*' at Oxford in the autumn
and began to prepare an exhibition of his collec-
tion of Turners, together with a selection of his
own drawings, for display at the Fine Art Society
in London the following February. This too was
an act of reiteration, recalling as it did both his

youthful work on Turner and his relationship with his father, with whom he had created the collection. At new year he was a guest at Windsor Castle of Prince Leopold, a trustee of the Ruskin School of Drawing, and followed this with a visit to the Gladstone family at Hawarden. (This personal encounter caused Ruskin to soften his attacks on Gladstone in *Fors Clavigera*, but there was no disguising the difference between Ruskin's ultra-tory views and Gladstone's Liberalism.) Ruskin's mental balance was slipping, and on 20 February 1878 he broke down completely: '*Mere* overwork or worry, might have soon ended me, but it would not have driven me crazy. I went crazy about St Ursula and the other saints,—chiefly young-lady saints' (*Correspondence of … Ruskin and … Norton*, 412).

Ruskin's delusions during his first attack of what has been characterized as either manic depression or 'paranoid schizophrenia' (Hunt, *The Wider Sea*, 370) were violent and extreme, revealing hostility to Joan Severn. Yet he was recovering by 8 April, and was able to complete his Turner catalogue. But although able to travel, he did not attend the hearing in London in November of the suit for libel brought against him by

James McNeil Whistler, pleading ill health. The previous June he had visited the newly opened Grosvenor Gallery, and in an ensuing number of *Fors Clavigera* he praised the work of Edward Burne-Jones but attacked Whistler's 'Nocturnes', accusing him of 'Cockney impudence' for asking 200 guineas 'for flinging a pot of paint in the public's face' (*Works*, 29.160). Whistler won a derisory farthing's damages, while Ruskin's legal costs were met by a subscription of his friends; but Ruskin found it a convenient reason for resigning the Slade professorship.

The portrait of Ruskin drawn by Hubert von Herkomer in 1879 shows the toll the previous years had taken. While his hair never went entirely grey, he let his side-whiskers grow, and after further illness in 1881 they became a full beard, so that as he aged, and his body became bent, he took on increasingly the appearance of a sage. It was at this period that Ruskin began to acquire self-conscious disciples, partly through the Guild of St George, and partly through the formation of organizations such as the Ruskin Society of Manchester (1879) and the Ruskin Reading Guild (1887). His preferred means of communication,

Fors Clavigera, resumed publication in March 1880.

Ruskin carried on desultory work on a number of part-publications as his recovery continued. In March 1880 he gave a lecture on snakes at the London Institution and in the summer worked on a somewhat eccentric series of articles for the *Nineteenth Century* published in 1880–81 as 'Fiction, fair and foul'. He made two visits to France, and on the second in October began work on *The Bible of Amiens* (1880–85), a mythographic history combined with close analysis of the sculpture of Amiens Cathedral that was intended as part of a larger unfinished work, *Our Fathers have Told Us: Sketches of the History of Christendom*. *Arrows of the Chace*, a collection of his letters to the press, edited by Alexander Wedderburn, was also published in two volumes in 1880.

Foreshadowed by troubling thoughts of Rose, on 19 February 1881 Ruskin suffered a second and violent attack at Brantwood, and attendants had to be called. He recovered by 22 March, and spent the rest of the year at his house, doing little work, but spending freely on the guild. He adopted the ladies' teacher-training college Whitelands in

Chelsea as the site of a May queen festival, a version of a former event at Winnington, and in 1885 the ceremony of choosing a rose queen was replicated at the High School for Girls in Cork. A companion, that is to say member, of the Guild of St George successfully established a wool mill on the Isle of Man on Ruskinian lines, and another began to revive the Langdale hand-spinning and weaving industry. In February 1882 Ruskin prepared a *General Statement Explaining the Nature and Purposes of St George's Guild* (1882), but in March he was struck down for the third time.

The storm cloud of the nineteenth century

This third attack, which took place while Ruskin was staying at Herne Hill, was less serious than the previous two. He remained under Joan Severn's care until August, when he began a tour to France, Switzerland, and Italy until December, accompanied by William Gershom Collingwood. Work was undertaken to enlarge Brantwood in order to accommodate the Severns, and his financial resources became overstretched. In Florence in October he met the American artist Francesca Alexander. He was enthused by her studies of

peasant life, and helped the publication of her
Story of Ida (1883), *Roadside Songs of Tuscany*
(1885—for which he bought and gave away many
of the original drawings), and *Christ's Folk in the
Apennine* (1888). He was already in contact by
letter with the illustrator Kate Greenaway, who
was to visit Brantwood in the spring of 1883
and receive praise in his next Oxford lectures,
but her feelings for him were not reciprocated.
Having indicated that he was prepared to return
to Oxford, on 2 January 1883 he was re-elected
Slade professor.

1883 was spent mainly at Brantwood, where
Ruskin was visited by Mr and Mrs La Touche,
except for excursions to London, to Scotland in
September, and to Oxford in March, May, and
November to deliver the lectures published as *The
Art of England* (1884). In restrained tones, Ruskin
reviewed the work of the artists he had known,
and praised a group of contemporary women illus-
trative artists. But he was unwell by the end of
the year, and the state of his mind was revealed
in the late *tour de force*, *The Storm Cloud of the
Nineteenth Century* (1884), based on a lecture
given twice at the London Institution in February
of that year. It was an extraordinary collision

between the public and the personal. Following fifty years of amateur meteorological observation, he stated that since 1871 a new 'plague-wind' (*Works*, 34.31) had begun to blow which had darkened the skies and, by implication, the mind of man. He found a moral metaphor in the foul winds recorded in his diaries which had an objective correlative in industrial pollution, but which was also a figure for his own mind. In the printed version, the second lecture is an annotation of and private commentary on the first.

Ruskin's attack in the lecture on the '*deliberate blasphemy of science*' (*Works*, 34.73) signalled the approach of the climax of his long battle with contemporary scientists, whose values he sought to counter with the mythopoeic botany, geology, and ornithology of *Proserpina*, *Deucalion*, and *Love's Meinie*. In the field of geology he defended the theories on the movement of glaciers of James Forbes (whom he had met in 1844) against the attacks of John Tyndall, an associate of T. H. Huxley. His principal quarrel was with the approach to scientific knowledge represented by Charles Darwin's *On the Origin of Species*, the subject of a symbolically important debate between Huxley and Bishop Wilberforce in

Museum, Oxford, was of special significance for
Ruskin. Not only had the debate emblematized
the end of the natural theology upon which the
building's decoration was premised, Ruskin used
its lecture hall as Slade professor, where he found
himself increasingly at odds with the 'Darwinian
Theory' (*Works*, 26.99).

Ruskin had known Darwin since 1837, and
Darwin, whom he respected, visited Brantwood
in 1879 and 1881, but his attacks on Dar-
winism became increasingly intemperate, while
he expressed an ever deeper revulsion against
anatomy. These matters came to a head at Oxford
in 1884. Wounded by the university's refusal to
support his plans to expand the drawing school,
he revoked a bequest made the year before. At
the same time he was drawn into the contro-
versy surrounding the proposal to equip a labor-
atory in the museum for the new professor of
physiology, Sir John Burdon-Sanderson, who held
a licence to practise vivisection. His Michaelmas
lectures, titled 'The pleasures of England', were
largely extempore disquisitions on the English
character which gave free rein to his anger and
disappointment, and became a spectacle for the

undergraduates. He was forcibly dissuaded by the university's vice-chancellor, Benjamin Jowett, from giving two announced lectures on science and atheism. When on 10 March 1885 the university agreed to fund the new physiology laboratories, Ruskin resigned his chair, and demanded the return of many of the additional works that he had placed in his school.

Praeterita and after

With letter 96, at Christmas 1884, Ruskin formally ceased publication of the now desultory *Fors Clavigera*, in order to concentrate his remaining energies on an autobiography whose title encapsulated his ever stronger mood of reiteration. Its subtitle—'Outlines of scenes and thoughts perhaps worthy of memory in my past life'—underlined his intention to recall only what pleased him, so that for instance his marriage received no mention. The work began to be published as it was composed, intermittently and in parts, in July 1885, and was never finished. In May 1886 he added another autobiographical dimension by publishing some of his raw material as *Dilecta: Correspondence, Diary Notes, and Extracts from Books Illustrating 'Praeterita'*

Praeterita is a delightful work, a rewriting of
Ruskin's life that makes it unreliable as a source
of biographical fact, yet an accurate portrait of
the author's mind. That it remained unfinished
shows that the contradictions of that mind never
achieved their desired synthesis, though this ver-
sion is the best that could be achieved, and
makes it a significant work of literature, most
especially in his Wordsworthian evocation of the
power of nature on the growth of a young mind.
The conscious manipulation of memory had been
intended to be therapeutic, but there were memo-
ries and hurts that could not be suppressed, and as
Ruskin struggled to bring them out he found him-
self fighting a double battle: to retain his sanity,
and to control the composition of a work that
increasingly alarmed Joan Severn.

At the end of July 1885, just as the first two
sections of *Praeterita* describing his family back-
ground and early childhood appeared, Ruskin had
a fourth, longer, and more severe attack of mad-
ness. Joan Severn responded by regulating his
correspondence and contacts, and attempting to

manage his finances, which were by now depen-
dent on the sale of his books. Faced with the
prospect of losing all control over his affairs
through permanent insanity, Ruskin reluctantly
prepared to make over Brantwood to Joan and
Arthur Severn, and appointed Joan, C. E. Norton,
and Alexander Wedderburn his literary executors.
Ruskin resumed publication of *Praeterita* in Sep-
tember and continued until July 1886, by which
time his account had reached 1844, but there was
increasing tension with the Severns over money.
In July 1886 he became violently mad again, but
published two further sections in October, one
in January and one in March 1887, bringing the
account up to 1847.

In May 1887, however, Ruskin quarrelled violently
with the Severns and temporarily left Brantwood
for the nearby Waterhead Hotel. The cause was
once more control over his estate and over the
composition of *Praeterita*. In spite of a reconcili-
ation, in August Ruskin, accompanied by his ser-
vant Peter Baxter, left Brantwood with the inten-
tion of going abroad, but instead he stopped at
Folkestone, and then settled in nearby Sandgate,
where he lived in reduced circumstances until
June 1888, forced to borrow money from his

publisher George Allen, who disapproved of Joan Severn's treatment of him. He made occasional visits to London, where he met Kathleen Olander. More parts of *Praeterita* appeared in June and November 1887 and May 1888, in the last of which he gave an account of his 'unconversion' of 1858 (*Works*, 35.496).

1858 was also the year he had first met Rose La Touche, making this a dangerous moment both for Ruskin and the Severns, who feared for his reputation. In June 1888, accompanied by Arthur Severn, Ruskin travelled to Abbeville and then in August, accompanied by the young architect Detmar Blow, set out on his old paths through Switzerland to Italy, writing an 'Epilogue' to *Modern Painters* at Chamonix (*Works*, 7.461–4). While visiting Francesca Alexander at Bassano he composed the chapter of *Praeterita* in which he described his first meeting with Rose. Upset by the past, and the rupture of his relationship with Kathleen Olander, Ruskin became increasingly depressed and by the time he reached Venice in October his mind was giving way again. He had returned as far as Paris in December when Joan Severn was called to fetch him home.

In May 1889 Ruskin left Brantwood for the last
time, accompanied by Joan Severn, travelling
to Seascale on the Cumberland coast where he
struggled to continue *Praeterita*, composing what
proved to be the final section, 'Joanna's Care',
devoted to the woman who had become his keeper.
In June 1889 the previous chapter, introducing
Rose, was published, followed by 'Joanna's Care'
in July, but in August he suffered another devas-
tating breakdown which lasted until August the
following year, bringing any hope of further work
to an end.

The years until Ruskin's death were spent at
Brantwood, in the Severns' protective custody,
anxiously monitored by his neighbour, W. G.
Collingwood. He was able to receive visitors, but
gradually retreated into silence, saying little, and
writing few letters. On the occasion of his eight-
ieth birthday in 1899 he was able to receive a
national address of congratulation sponsored by
almost all the organizations with which he had
been associated, read by the secretary of the Birm-
ingham Society, John Howard Whitehouse, who
was to protect his legacy in the lean years of
Ruskin's reputation in the first half of the twen-
tieth century.

On 18 January 1900, now confined to his bedroom, Ruskin caught influenza from one of the servants, and he died peacefully in the afternoon of 20 January. Although a burial in Westminster Abbey was offered, Ruskin was buried in accordance with his wishes in Coniston churchyard on 25 January 1900.

Ruskin's legacy

During Ruskin's final years his reputation as a sage steadily grew as his values were absorbed by a wide range of turn-of-the-century reformers. His early advocates were those serious minded young men who had taken part in the Hinksey road scheme or heard him lecture at Oxford. His Hinksey foreman, Arnold Toynbee became a pioneer of university extension lectures before his untimely death in 1883. The cause was taken up within the wider context of educational reform by Michael Sadler, Arthur Acland, Hubert Llewellyn Smith, and G. W. Hudson Shaw, who became the first chairman of the Workers' Educational Association in 1903.

In 1884 Oxford University established a university settlement in East London, naming it Toynbee

Hall, which, alongside the university extension movement, became a nexus for those who had felt Ruskin's influence at first and second hand, among them Edward Urwick, T. Edmund Harvey and J. H. Whitehouse. Two others based at Toynbee Hall during its most Ruskinian period were future architects of the welfare state, Clement Attlee, who became prime minister in 1945, and William Beveridge, author of the 1942 report that laid its foundations. Sidney and Beatrice Webb were influenced by Ruskin in their early years. Richard Titmuss, who developed the post-World War II discipline of social administration in the context of the new welfare state, acknowledged Ruskin's contribution to the shaping of his thought.

Ruskin's approach to economics was sustained by the economists J. A. Hobson and William Smart, his views on social welfare by John Brown Paton and John Lewis Paton, father and son, who founded the British Institute of Social Service. To the overlapping circles of university extension teaching and Toynbee Hall should be added the spread of Ruskin reading guilds through Britain's provincial cities, linked by the journal *St George* (1898–1911). Ruskin's works also became

widely available in cheap editions. In 1877 a second edition was issued of the key text for his social criticism, *Unto this Last*. The first edition had sold only 1000 copies in ten years, but the impact of recession and harsher industrialization in the 1880s meant that the text found a new audience among working-class readers, who, made familiar with its biblical tone by non-conformism, adopted Ruskin's language to express their own anti-capitalist arguments. In 1904 Mahatma Gandhi read *Unto this Last* in South Africa, and experienced a conversion that led to practical experiments and the publication of his paraphrase in Gujarati in 1908. Other foreign admirers were Leo Tolstoy, and Japanese Christian Socialists in the 1920s.

Ruskin's political and educational influence was also marked by the foundation by two American philanthropists of Ruskin Hall (now College) at Oxford in 1899, as an independent teaching institution for working class students. When the representatives of the labour movement took their seats in parliament in significant numbers for the first time in 1906, a survey of forty-five Labour and Liberal MPs named Ruskin more than any other author as a source of ideas.

As has been shown, William Morris had already served as a conduit for Ruskin's political and aesthetic values. Together they had a shaping influence on the Arts and Crafts movement, led by C. R. Ashbee and others, which flourished between 1880 and 1910. In 1884 a group of Ruskin-influenced architects, painters, sculptors, and designers formed the Art Workers' Guild. A prominent member, William Lethaby, became the first professor of design at South Kensington, marking the final triumph of Ruskin's ideas over the utilitarian views of Henry Cole, for in 1896 Cole's National Art Training School became the Royal College of Art, dominated by the Arts and Crafts movement until the First World War.

Ruskin's literary influence is less easy to quantify, though there are arguments that his ideas form a bridge to early literary modernism, rather than serving as a cause of counter-reaction, in spite of E. M. Forster's mocking of the clerk Leonard Bast's reading of *The Stones of Venice* in *Howards End* (1910). Probably his most important literary disciple was Marcel Proust, not because Proust wrote like Ruskin, but because through the practical work of translating into French *The Bible*

of Amiens (1904) and *Sesame and Lilies* (1906),
Proust began to arrive at his own style.

The apogee of Ruskin's immediate influence was marked by the decision to publish a monumental Library Edition of his complete works in thirty-nine volumes, edited by E. T. Cook and Alexander Wedderburn, which appeared between 1903 and 1912. Although biographically reticent and presenting a liberal version of Ruskin (as did Cook's entry in the original *Dictionary of National Biography*), this became the foundation for future Ruskin scholarship. The edition was not a commercial success, however, as Ruskin's reputation slowly began to sink into a trough as a result of generational change and a reaction against Victorian ideas. Ruskin's centenary was celebrated with exhibitions, lectures, and publications in London and Oxford in 1919, but the recent war had made his ideas seem distant.

Ruskin's long-suffering guardians (and censors), Joan and Arthur Severn, had immediately begun to disperse their inheritance, a process accelerated after Joan Severn's death in 1924, and completed after Arthur's in 1931, which left Brantwood empty, its treasures scattered in Britain, America,

and Japan. Brantwood was eventually bought
by J. H. Whitehouse, who almost single-handed
fought to protect Ruskin's material and intellec-
tual legacy. In 1919 he had founded Bembridge
School on the Isle of Wight, on Ruskinian prin-
ciples. There in 1929 he built the Ruskin Galleries
to house a growing collection of Ruskin manu-
scripts and other material. Brantwood was opened
as a public memorial to Ruskin in 1934. Over the
years many of the objects dispersed from Brant-
wood have been returned and the house presents
changing displays featuring Ruskin's drawings
and aspects of his ideas. In the 1990s work began
on restoration of the gardens and the development
of the estate to reflect Ruskin's views on ecology
and conservation.

Whitehouse's collection continued to grow even
after his death in 1955, when chairmanship of
the Education Trust Ltd, owners of the collec-
tion, passed to a former Bembridge pupil, R. G.
Lloyd (later Lord Lloyd of Kilgerran). In 1957 J. S.
Dearden was appointed curator. Shortly before
Lloyd's death in 1991 agreement was reached with
Lancaster University for the transfer of the Bem-
bridge archive to a purpose-built building on the
campus, and in 1993 the Ruskin Foundation was

created to manage the collection, on loan from the
Education Trust. The Ruskin Library, designed by
Richard MacCormac, opened at Lancaster Univer-
sity in 1998.

Although he was always the object of biographical
interest, scholarly study of Ruskin did not begin
to revive until the late 1950s. Popular interest was
stimulated by the publication of three volumes
of letters relating to Ruskin's disastrous marriage,
skilfully edited into a narrative by Mary Lutyens
(*Effie in Venice*, 1965, *Millais and the Ruskins*,
1967, and *The Ruskins and the Grays*, 1972).
With most of Ruskin's work long out of print, in
1964 Kenneth Clark published a substantial antho-
logy of quotations, *Ruskin Today*. New standards
of Ruskinian editing were set by Van Akin Burd, of
the State University of New York at Cortland, with
his edition of Ruskin's letters to the headmistress
and pupils of Winnington School, *The Winnington
Letters* (1969), and the masterly two volume *The
Ruskin Family Letters, 1801–1843* (1973).

The principal focus of scholarly attention was
on Ruskin as a Victorian aesthetician, but as
the breadth of his interests, from natural sci-
ence to natural theology, became known to a

new generation of researchers in Britain and America, the inter-disciplinary nature of Ruskin's approach chimed with the new spirit of the 1960s, while Ruskin's anti-industrialism and pro-environmentalism also appealed to that generation. The new disciplines of cultural history and social art history owe something to his influence. In 1969 J. S. Dearden organized a week-long conference at Brantwood, bringing together scholars from America, France, Britain, and Japan. The success of this conference led to the formation of the Ruskin Association, a worldwide linking of Ruskin scholars through a newsletter. The Ruskin Association was formally dissolved in 2000, when the celebrations of that year seemed to show that Ruskin's works had regained their former position.

From the 1970s onwards critical studies, biographies, and exhibitions had multiplied, so that when the centenary of his death was celebrated in 2000 interest in his ideas—though now in a completely different context—stood almost as high as it had in 1900. The endless fascination of Ruskin's private life was seen alongside his power as a visual artist, as a cultural critic, and a social polemicist. The newly named Tate Britain made Ruskin the focus of its first large loan exhibition,

organizations and institutions linked to Ruskin by
foundation or association marked the centenary in
some way. The Guild of St George, which, while
retaining some land from the original foundation,
had concentrated its work on social welfare and
education, launched the Campaign for Drawing,
a practical expression of Ruskin's belief in the
value of training the hand and the eye that sub-
sequently became an independent organization.
A new, informal umbrella organization, Ruskin
To-Day, was brought into being to co-ordinate the
2000 programme, and it continues to promote
the communication of Ruskin's ideas and values.
In September 2006 it held a conference under
the title, *'There Is No Wealth But Life': Ruskin in
the 21st Century.* Nine distinguished public figures
were commissioned to write and discuss essays
on Ruskinian themes, with a view to exploring
both the theoretical and practical applicability
of Ruskin's aesthetic, social, and moral views to
modern times.

Through the widespread diffusion of his ideas on
social reform, and the interdisciplinary nature of
his art criticism, Ruskin can fairly be said to have
had a hand in shaping the culture of the twentieth

century, just as he did that of the nineteenth, and there is reason to believe that he may yet make a contribution to that of the twenty-first century. The reason for his lasting appeal was his combination of moral certainty and intellectual openness, and his ability to inspire love in those who understood his motivations. His wisdom is summed up by his abiding paradox: '*No true* disciple of mine will ever be a "Ruskinian"!' (*Works*, 24.371).

Sources

The works of John Ruskin, ed. E. T. Cook and A. Wedderburn, library edn, 39 vols. (1903–12) · V. A. Burd, ed., *The Ruskin family letters*, 2 vols. (1973) · *The letters of John Ruskin to Lord and Lady Mount-Temple*, ed. J. L. Bradley (1964) · *The Winnington letters: John Ruskin's correspondence with Margaret Alexis Bell and the children at Winnington Hall*, ed. V. A. Burd (1969) · *The correspondence of John Ruskin and Charles Eliot Norton*, ed. J. L. Bradley and I. Ousby (1987) · H. G. Viljoen, *Ruskin's Scottish heritage* (1956) · T. Hilton, *John Ruskin: the early years* (1985) · T. Hilton, *John Ruskin: the later years* (2000) · D. Leon, *Ruskin: the great Victorian* (1949) · *Effie in Venice: unpublished letters of Mrs John Ruskin written from Venice between 1849–1852*, ed. M. Lutyens (1965) · M. Lutyens, *Millais and the Ruskins* (1967) · M. Lutyens, *The Ruskins and the Grays* (1972) · V. A. Burd, *John Ruskin and Rose La Touche* (1979) · V. A. Burd, *Ruskin, Lady Mount-Temple and the spiritualists* (1982) · J. L. Bradley, ed., *Ruskin: the critical heritage* (1984) · J. D. Hunt, *The wider sea: a life of John Ruskin* (1982) · *The diaries of John Ruskin*, ed. J. Evans and J. H. Whitehouse, 3 vols. (1956–9) · *The Brantwood diary of John Ruskin*, ed. H. G. Viljoen (1971) · *Ruskin in Italy: his letters to his parents, 1845*, ed. H. I. Shapiro (1972) · *Ruskin's letters from Venice, 1851–52*, ed. J. L. Bradley (1955) · *Letters from the continent, 1858*, ed. J. Hayman · *Sublime and instructive: letters from John Ruskin to Louisa, marchioness of Waterford, Anna Blunden and Ellen Heaton*, ed. V. Surtees (1972) · P. Walton, *The drawings of John Ruskin* (1972) · J. S. Dearden, *Facets of*

Ruskin (1970) · J. S. Dearden, *John Ruskin's Camberwell* (1990) · J. S. Dearden, *Ruskin, Bembridge and Brantwood: the growth of the Whitehouse collection* (1994) · J. S. Dearden, *The portraits of John Ruskin* (1999) · M. D. Wheeler, *Ruskin's God* (1999) · J. L. Bradley, *Ruskin: a chronology* (1977) · G. P. Landow, *The aesthetic and critical theories of John Ruskin* (1971) · G. P. Landow, *Ruskin* (1985) · R. Hewison, *John Ruskin: the argument of the eye* (1976) · R. Hewison, *Ruskin and Venice* (1978) · R. Hewison, *Ruskin and Oxford* (1995) · R. Hewison, I. Warrell, and S. Wildman, *Ruskin, Turner and the Pre-Raphaelites* (2000) [exhibition catalogue, Tate Gallery, London, 9 March–28 May 2000] · D. Birch, ed., *Ruskin and the dawn of the modern* (1999) · R. B. Stein, *John Ruskin and aesthetic thought in America, 1840–1900* (1967)

Index

Enjoy biography? Explore more than 55,000 life stories in the Oxford Dictionary of National Biography

The biographies in the 'Very Interesting People' series derive from the *Oxford Dictionary of National Biography*—available in 60 print volumes and online.

To find out about the lives of more than 55,000 people who shaped all aspects of Britain's past worldwide, visit the *Oxford DNB* website at **www.oxforddnb.com**.

There's lots to discover ...

Read about remarkable people in all walks of life—not just the great and good, but those who left a mark, be they good, bad, or bizarre.

Browse through more than 10,000 portrait illustrations— the largest selection of national portraiture ever published.

Regular features on history in the news—with links to biographies—provide fascinating insights into topical events.

Get a life ... by email

Why not sign up to receive the free *Oxford DNB* 'Life of the Day' by email? Entertaining, informative, and topical biographies delivered direct to your inbox—a great way to start the day.

Find out more at www.oxforddnb.com

'An intellectual wonderland for all scholars and enthusiasts'

Tristram Hunt, *The Times*